PRAISE FOR
JIM SHEPARD

"Let's hope Shepard becomes as influential
as he should be. He's the best we've got."

—DAVE EGGERS

"Shepard's project is always to push toward that sense of
wonder and the 'high hopefulness' of purpose that ordinary
people have always brought to the project of living—to give us
through fiction a sense of profound empathy that the historical
record alone cannot. He most stunningly succeeds."

—LISA ZEIDNER, *The Washington Post*

"One of this country's greatest fiction writers."

—MICHAEL SCHAUB, NPR

"Shepard's writing is lean, assured, never canned;
it is sometimes cinematic and often astringently funny. He
reconstructs the ordinary and offers the surreal as a given,
[finding] highly original ways into the most moving stories."

—AMY HEMPEL

THE TUNNEL AT THE END OF THE LIGHT

THE
TUNNEL
AT THE
END
OF THE
LIGHT

ESSAYS ON MOVIES
AND POLITICS

JIM SHEPARD

 TIN HOUSE BOOKS / Portland, Oregon & Brooklyn, New York

Copyright © 2017 Jim Shepard

Published by Tin House Books, Portland, Oregon, and Brooklyn, New York

Distributed by W. W. Norton & Company

Library of Congress Cataloging-in-Publication Data

Names: Shepard, Jim, author.
Title: The tunnel at the end of the light : essays on movies and
 politics / by Jim Shepard.
Description: Portland, OR : Tin House Books, [2017] | Includes
 bibliographical references and index.
Identifiers: LCCN 2017028270 (print) | LCCN 2017010540 (ebook)
 | ISBN 9781941040720 (alk. paper) | ISBN 9781941040737
Subjects: LCSH: Motion pictures—Philosophy.
Classification: LCC PN1995 .S4859 2017 (ebook) | LCC PN1995
 (print) | DDC 791.43019—dc23
LC record available at https://lccn.loc.gov/2017028270

First US Edition 2017
Printed in the USA
Interior design by Jakob Vala

www.tinhouse.com

For John, who knows more about movies
than anyone I've ever met.

CONTENTS

INTRODUCTION

"If it was anybody else, I'd say what was going to happen to you would be a lesson to you. Only you're going to need more than one lesson. And you're going to get more than one lesson."

—Boss Jim Gettys to Charles Foster Kane, *Citizen Kane*

How resourcefully pessimistic would you need to have been to have predicted in 2007 that as early as 2017, George W. Bush's administration would appear benign by comparison with an administration headed by Donald Trump? Nearly everything about that Bush administration represented for American politics and the American people what Charles Foster Kane might have called "a new low—have you got that, Jedediah? A new low"—and all of it portended a disastrous direction that the American ship of state was headed. But who could have imagined that our democracy would be tipping off the edge of Victoria Falls *this* quickly?

In 2003 Dave Eggers wrote me to say he was starting a monthly magazine, *The Believer*, which would feature long book reviews, articles, and interviews, as

well as a lot of political writing, especially concerning anti-war efforts. He wanted to know if I would consider contributing to it regularly, writing about movies. He'd heard about my film teaching from some of my former students who were now working with him, and he'd heard about the way I incorporated movies into my talks about literature. When I got back in touch with him I told him I wasn't interested in being a movie reviewer, and he made it clear that that wasn't what he'd had in mind, and eventually we settled on the idea of essays about the ways in which mostly American movies from various periods illuminated current political concerns. I started with *Badlands*, a movie that had always seemed to me to get at something essential about how truly and lethally weird Americans really are, and from there I was off and running. Did anything capture the high-spirited *glee* of American ruthlessness better than *GoodFellas*? Was there anywhere a more accurate portrait of the lunatic serenity of our leaders' conviction—in the face of all evidence and their own lack of knowledge—than could be found in *Lawrence of Arabia*? For about four years, I had a lot of fun writing those essays and got a lot of gratifying feedback on them, my favorite probably being a postcard the editors forwarded to me from Kurt Vonnegut

on which he had written only *God bless Jim Shepard!*
Then a few years ago, while we stood around at the
Tin House Workshop sloshing drinks on one another,
editor Tony Perez broached the idea of assembling
all the essays into one collection. They certainly still
seemed timely, given that, even after two terms of a
Democratic administration, nearly all of the critiques
still felt painfully relevant. Sure, I told him: if you guys
are okay with doing all of this work and not making
any money, so am I.

As anyone doing cultural criticism these days might
have predicted, these essays are mostly about the power
and resilience of the lies we tell ourselves as a collective.
Movie genres emerged as a kind of implicit ongoing
conversation between audiences voting with their feet
and moviemakers doing what they could to standard-
ize expectations and build on past successes. As those
conversations became more refined, film genres began
to appeal less to our experience of reality and more to
the rules of the genres themselves; in other words, they
created their own fields of reference.

And is it possible to imagine an administration
that would foreground that issue more spectacularly
and urgently than our current one? We now con-
front a regime that presents as its public face hacks

and sociopaths who have no trace of shame about lying directly in the face of contradictory evidence. Of course, in many ways the veteran political scientist's response to that would be: So what's new about that? Americans have been covertly demanding this for years, but recently a large percentage of us have come very close to just telling our leaders and media: *don't tell me the truth anymore, and if you do, I'm going to get enraged.* And now that's earned us a government that has openly declared war on the free transfer of information and has set about punishing any allegiance to what it considers unpleasant truths. This is what empires do at the end: they refuse to face the facts that the world is changing and they no longer have unlimited hegemonic power. And of course citizens are encouraged to refuse to face those facts by their leaders, who find denying the truth infinitely easier than answering questions about why they can't change it.

The models on display in these movies—the sentimental sociopath, suffused with self-pity; the feckless cipher bereft of any inner life who defines himself, then, by aggressive action; the isolated narcissist who imagines himself as a Hero in Disguise and takes as a matter of course his primacy over others; the movers and shakers who are now open and ebullient in their rapacity

and ruthlessness; the megalomaniacs whose monstrous assurance steamrolls any doubt generated by the world of contradictory facts; the willed innocents who wreak havoc obliviously, with an outraged sense of their own virtue; and the ideologues who've been proven wrong time and time again but have reassured their supporters precisely by their inability to learn, by their insistence that they're no wafflers—at this point they're all mostly governing us, in both senses of the word.

Looking at these movies and what they're selling us is a little bit of help, in other words, when it comes to figuring out how we got here. And where are we now, and where are we headed? In one sense, there's never been greater uncertainty as to what lies ahead or what we can predict. Eight years of this president seems as likely or unlikely as his impeachment in year one. Are we really going to attack Iran? Start a war with China over some islands in the South China Sea? Register all Muslims? Outlaw protest? Bomb back to the Stone Age any spot in the Middle East where three guys from ISIS pop up in a truck? But in another sense, it's all too clear what's coming. The Republican elite has already abandoned what tiny vestigial traces of integrity it might have had remaining—think of John McCain, who likes to tell himself over and over

again that the one thing he won't countenance is torture, having buttoned up his lip and gone along for the ride with Mike Pompeo as head of the CIA; or Lindsey Graham, that old Cold Warrior, now sitting on his hands when faced with the real possibility that the leader of his party is Vladimir Putin's puppet—which now means that all three branches of the government will be acting with full vigor to undermine, if not destroy, American democracy, American constitutional rights, and the physical American landscape. The Republicans have also long understood their own minority position, so, given that agenda, we can expect much more rigorous attempts at gerrymandering and voter suppression. With political change then foreclosed, that leaves the shutting down of information. We're already facing an unprecedented assault on investigative journalism, and this new administration's choice to head the FCC has already announced his determination to do what he can to stamp out the freedoms of the internet. Just four days after the new administration took power it instructed federal employees to cease communicating with the public through news releases, official social media accounts, and correspondence. Somebody's been studying up on their authoritarian regimes: if step one is

to refuse the press access in all but the most tightly controlled ways, step two is to shut down the leaks.

The Republican Party has for decades claimed that the American government is the implacable enemy of the American people. This administration is working to make that statement true for the first time for a very large majority of citizens.

That leaves the streets, and we can already see what's in store for us there. The militarization of the police over the last forty years, begun with the war on drugs and amped up a thousandfold by the war on terror, was never really about threats from without and has always been about anticipating threats from within: as in, What happens when economic inequality and political irrelevance become *so* grotesque that they lead to civic unrest? The solution to that problem, for the Republicans and the corporate Democrats who have held power, has never been, *So I guess we should do something to alleviate economic inequality.* It's always been, *When the have-nots have nothing left but the streets, we need to be ready to take the streets away as well.* And of course the exponential growth of the surveillance state will help with that. Hence our leaders' seeming lack of concern over the last decade or so about all the metadata about US citizens—citizens

who haven't been suspected of a crime—that's being hoovered up.

And so, even before our forty-fifth president assumed office, one of his party's minions, Washington state senator Doug Ericksen, an early outspoken supporter of the current president, proposed a bill that would allow authorities to charge protesters with "economic terrorism," with violators facing up to five years in prison. There will be a lot more of those kinds of bills. Already North Dakota state representative Keith Kempenich—whose name deserves to be recorded here as yet another nominee for the American Shit Weasel Hall of Fame—has introduced an even more ethically repulsive bill that would allow motorists to run over and kill any protester obstructing a highway, as long as they did so "accidentally." And we note that those 230 protesters—along with, as of this point, six journalists—who were arrested during the inauguration protests have been charged with felony rioting, which carries a maximum sentence of ten (!) years. The coming unrest, mostly in the cities, will be portrayed in the heartland by Fox News and our president's tweets as more proof of the unmotivated lawlessness that should terrify the country and that justifies the further erosion, if not the elimination, of

our civil liberties. And the balkanization of our information sources will ensure that Americans can never really negotiate their differences in any adequate way, because they no longer share not only a world view but also basic facts.

I teach at a liberal arts institution—Williams College—and found myself facing two different classrooms full of devastated students the morning after the 2016 election. I told them that it was hard, at that point, as an educator—by then I'd been teaching for thirty-six years—not to feel like part of a massive failure. I told them that they were all going to be facing some very difficult decisions much sooner than I would have guessed they would be. I told them that our government was in the process of morphing into something that was going to further exalt and pursue many of our worst instincts as individuals and as a collective. And that that government had already begun the process of accruing unto itself the power to make things extremely unpleasant for everyone who decided that, in all good conscience, they were going to have to resist that agenda.

So I told them to start considering even then which actions their government might take that would cause them to say, *This I will not stand by and let happen.* And

to start considering as well, in those cases, just how much of their own comfort and safety they were going to be willing to risk, or to forfeit, to assert those values.

As to which American movies have been the most prescient about our current moment—whether it's *Chinatown*, ending with its police lieutenant shouting, after everything has gone so grotesquely wrong for its hero, "Get off the streets! Get off the streets!" or *Apocalypse Now*, with its protagonist's "Who's the commanding officer here?" being answered with, "Ain't *you*?" or *Night of the Living Dead*, with its sheriff, heading the posse that just shot the movie's hero in the head, pronouncing "Okay, he's dead. Let's go get him. That's another one for the fire"—we're about to find out.

But here we are again, where the movies always leave us: trying to have it both ways and flopping around in the middle of both reality *and* escape. Another iconic moment in American film history that would seem to apply to where we are now is Bette Davis's famous warning from *All About Eve*: "Fasten your seatbelts. It's going to be a bumpy night." Except we can no longer settle for buckling in at this point, since it's been our passivity—a collective trait that the movies, whatever their educative value, mostly enhance—that has enabled this state of affairs to begin with.

BADLANDS AND THE "INNOCENCE" OF AMERICAN INNOCENCE

laconic: a. Short, pithy, curt, epigrammatic, terse.
taciturn: a. Habitually silent; not apt to talk.
sociopathic: a. From the noun: a psychopathic personality
 whose behavior is aggressively antisocial.

A few moments after it opens, *Badlands* locates its hero, Kit—Martin Sheen, twenty-six years before he became our Wednesday night president—standing over a dead dog and not reacting the way we would hope. His opening lines have to be some of the most idiosyncratic any hero's ever uttered in a Hollywood movie. He says to a fellow garbageman, "Give you a dollar to eat this collie." He sounds serious. And it's a measure of the kind of world we're in that the garbageman answers that it would take more than a dollar. And that that isn't a collie, anyway.

Until his recent uptick, Terrence Malick hadn't made many movies—only four in the first thirty-some years of his career. Mostly because *Badlands*—which he wrote, produced, and directed in 1973—was his first, he always remained a cult figure.

The story is based on the Starkweather-Fugate kill-
ing spree in the midwest in the late '50s. Most of the
movie's details are taken from that dismal saga of two
sociopathic dimwits—Charles Starkweather and Caril
Ann Fugate—who killed eleven people for no good
reason before being caught. And *Badlands* wants to
suggest that there was something peculiarly American
about their dimwittedness and the particularly lethal
forms it took. *Badlands* was the first movie to really
taxonomize a particularly American species, a species
which right about now could use some taxonomizing:
the sentimental sociopath.

For decades there'd been movies about *young peo-
ple in love and on the run, living off their guns*, but
they'd all had one thing in common: the couple had
always been forced into violence by accident or cir-
cumstance. You know the drill: they just wanted to
rob a store or bank, sometimes for kicks, sometimes
to eat, but some unpleasant establishment type tried
to take them out, and next thing they knew, they'd
killed somebody. They'd never meant to *hurt* any-
body. Now they had to *keep* killing. In other words,
they were killers you could root for.

Kit and Holly—a teenage Sissy Spacek in a role
that mobilized all of her girl-next-door spaciness in

4

the most unsettling ways—are not. They're not forced to kill and they're not fazed by killing. Mostly they feel bad for themselves. As far as they're concerned, they're the most admirable people they know. And that's because they never think about anybody else.

Badlands was—and still is—amazing for its insight into the ways in which a kind of hopelessly shallow romanticism, leached down from pop culture, intersects sinisterly with—and in fact, may even help *enable*—sociopathic behavior. "He wanted to die with me, and I dreamed of being lost forever in his arms," Holly tells us in her voice-over, and we transition from that to her killing a pet catfish for no apparent reason by pitching it outside. ("The whole time the only thing I did wrong was throwing out my fish," she adds, and we watch it gasping and struggling in a melon patch.) "I didn't mind telling Kit about stuff like this, 'cause strange things happened in his life, too," she confides, and we see Kit standing (!), experimentally, off and on a sick cow lying on its side. "And as he lay in bed, in the middle of the night, he always heard a noise, like somebody was holding a seashell against his ear. And sometimes, he'd see me coming toward him in beautiful white robes, and I'd put my cold hand on his forehead," she adds, but what we're *looking* at is Kit on his

bed giving off the blankest of blank stares—something in the lobotomized range. That gives way to their first sexual encounter, a disappointment to them both. And yet, Kit knows that such encounters are supposed to be memorialized. And how would he like to memorialize it? "We should crunch our hands with this stone," he tells her. "That way we'd never forget what happened today." To which Holly replies, maybe a little too matter-of-factly, "But it would hurt." "That's the point, stupid," he tells her. And she takes issue not with his suggestion, but with having been called stupid. So he decides to memorialize the moment by keeping the rock with which he *would've* crushed her hand. Except that it's too big. So he keeps a different one.

"What's gonna happen to Jack and me?" one of their victims, a girl exactly Holly's age, asks her, as she's heading off toward her doom. The boys walk ahead: just two couples, kickin' stones and makin' small talk. Holly answers that she'll have to ask Kit, and asks if the girl loves her boy. Then she remarks, "I gotta stick by Kit. He feels trapped." "I can imagine," the girl answers, and we get a sense of just how understated this movie's black humor can be. But Holly doesn't register the irony. In fact, her response makes clear just how

far from normal human empathy she resides: "Well, *I've* felt that way. Haven't *you*?"

Building a mainstream Hollywood movie around that kind of stunted, bonsai version of affect was nervy and memorable enough to have spawned a whole genealogy of imitators. It's a subgenre we all might have been better off without, but, either way, all of those blank-eyed and sociopathic teens we've watched take in horrors without batting an eye, from *River's Edge* to *Natural Born Killers* to *Kids*, are variations on Kit and Holly.

But there were other aspects of our pop culture with which *Badlands* had issues. In 1973 the Hollywood Western was already seventy years old, having begun in the Roosevelt administration with *The Great Train Robbery* in 1903. Some part of its longevity has had to do with its usefulness in interrogating a particular set of incoherencies and paradoxes residing within our national self-image. Real Americans, Americans believe, are all about cooperation and teamwork; real Americans are rugged individualists. Real Americans are law-abiding, and real Americans occasionally feel the need to take the law into their own hands. Real Americans fight to make communities safe for habitation, and then

real Americans seem to get pretty antsy at the notion of settling down in one of those communities.

All of that sounds mighty familiar to marginal characters like Kit. They're the same incoherencies that he's been flummoxed by in his own way.

The Western hero is fundamentally antisocial. That's why we love him. He makes his own rules. That's why we love him. But those are also, we notice, characteristics of villains and sociopaths. The Western hero doesn't think; he just acts. That's why we love him. Kit tells Holly when he first meets her and he's trying to explain why he's special, "I've got some stuff to say. Guess I'm lucky that way." But he doesn't really mean that he has stuff to *say*. He gets a chance to speak, later, to provide his version of things on one of those do-it-yourself records, and he finds that he can't even fill up a minute's worth of time. If he intends to get noticed, he realizes, he needs to have stuff to *do*.

At one point well into their killing spree, Holly tells us in voice-over that they lived in utter loneliness, but that Kit informed her that *solitude* was a better expression for what she wanted to say. The distinction's not a minor one, for Kit: solitude, he registers, is less needy than loneliness; solitude grants isolation its dignity by leaving open the possibility that it was a choice.

8

The Western hero is someone who owns almost nothing but his one set of clothes and his gun; someone for whom the terms poverty, or rootlessness, don't seem to apply as pejoratives. He is *not* shiftless. He is *not* a failure. He's *outside* social hierarchies. An appealing prospect if, like Kit, your alternative seems to be garbageman.

"Well, I know what my daddy's gonna say," Holly tells him soon after they meet when he asks if he can see her again. "What?" he asks. "That I shouldn't be seen with anybody that collects garbage," she tells him.

Fifty years ago in an essay called "Movie Chronicle: The Westerner," a critic named Robert Warshow put his finger dead on the center of what's most bizarre, and for Americans, mesmerizing, about the figure of the Western hero.

As he saw it, what the Western hero fought for, in the final analysis, was the purity of his own image: his honor. When the gangster was killed, Warshow wrote, his whole life was shown to have been a mistake, but the image the Western hero sought to maintain could be presented as clearly in defeat as in victory; he fought mostly to assert what he was, and he had to live in a world that permitted that statement. What was corner-turning about Warshow's essay was the way it explained

what was persistently elegiac about the form, since in his formulation the hero was fighting not to extend his dominion but to assert his personal value, and his tragedy lay in the fact that even that circumscribed demand could not be fully realized. Warshow reminded us, in other words, about just how monomaniacally the genre was concerned with *style*. It wasn't violence at all that was the point, but a certain image, a style, which expressed itself most clearly in violence.

Part of the resilient appeal of John Wayne in *Stagecoach*, Alan Ladd in *Shane*, or Henry Fonda in *My Darling Clementine* is the appeal of the paradox of the affable man with the gun. *The affable man with the gun*: that's a prototype to which Kit is trying to aspire.

But the aspect of the Western hero that may hold the most appeal for Kit, and for America, may be his essential inarticulateness. The Western hero doesn't trust words. What's he say when asked why he does what he does? That a man has to do what a man has to do. Well, thanks. John Wayne's character in *Stagecoach*, the Ringo Kid, is an outlaw. How'd that happen, anyway, to such an apparently decent guy? Well, here's his explanation for it: "Well, I used to be a good cowhand," he explains to Dallas, the fallen woman who thinks he's swell, "but . . . things happen." "Yeah," Dallas agrees, by

all appearances thinking about her own apparently inexplicable situation. "That's it. Things happen."

For how many years now in our national consciousness has John Wayne been pretty much the gold standard when it comes to images of easygoing and self-assured masculinity? And what was he selling, exactly?

Partly, at least, the way real men turn *can't explain* into *won't explain*. The way real men disdain explanations. Explanations are for schoolteachers, shopkeepers, the emasculated. Consider Donald Rumsfeld's face, in any of his press conferences, when he was asked to pursue the logic of one of his statements.

Kit's justification for quitting his job is "Just seemed like the right move." "How's he doing?" Holly asks him after he has shot his best—and maybe only—friend, and he answers, "Got him in the stomach."

America's always been full of guys who feel like they've been shown their whole lives that they're outsiders; who know they're anachronisms; who know that the only real choice they probably have before them is *how* to get swept aside. Kit goes from garbageman to cowhand, and doesn't catch on at that, and when he's asked at the unemployment agency what kind of work he thinks he's qualified for, he has to say, "Can't think of anything at the moment." His first act of rugged individualism in the

movie is to wander off his job with the garbage truck. Which he explains immediately to Holly: "Quit my job. Well, I'm going to work as a cowboy, now."

If that's what he wants, in the American Western, even more than he needs a horse, and *certainly* more than he needs a cow, he needs a gun.

His and Holly's killing spree opens with his visit to Holly's house, and his confrontation with Holly's father, played by the dimly sour and crankily suspicious Warren Oates, back in action just four years after his own memorable performance as a sociopath—the pea-brained Lyle Gorch—in Sam Peckinpah's *The Wild Bunch*. Holly and her father return to their house to find Kit wandering through the upstairs. He's started to pack her things.

Holly's father asks a reasonable question: "What're you doing?" Kit's answer is, "Got a gun here, sir. It's always a good idea to have one around."

He's trying out roles, whether it's the hero who saves the princess in the tower, or the Western hero. "Suppose I shot you?" he asks Holly's father. "How'd that be? Huh?" And we understand, as an increasingly frightened Holly's father understands, that Kit really doesn't know. "Want to hear what it sounds like?" he asks, and the weird, hollowed-out metallic ring of the

gunshot in the enclosed space of the staircase jolts us as much as them.

Holly's father attempts a sort of dignified run for it, to get help. Kit shoots him. He dies there in the living room, Holly's hands on his cheeks.

Which brings us to this essay's opening definitions. The first two—laconic and taciturn—are adjectives wearyingly applied to Western heroes. The third, sociopathic, is the word often chosen to describe serial murderers. When you make a movie about a misfit wanderer who shoots people when he feels emotionally stymied—like, say, Billy the Kid—that's precisely the line you're straddling. As far as Kit can tell, Western heroes don't talk much, can't really express themselves, kill people periodically, and can't always fully articulate why. Now *there's* a career path in which he *can* imagine himself.

In the sequence following the shooting of Holly's father we trail Kit across that spectrum of adjectives, all the way to the dysfunctional. First he's taciturn, and doesn't say much at all. He walks back and forth, puts an unlit cigarette in his mouth, exercises his shoulders. He and Holly find themselves in the kitchen. "How bad off is he?" Holly asks him. "I can look and see," Kit answers. Going out for a walk, he offers her something

laconic in the face of possibly dire consequences: "You want to call the police," he tells her, "that's fine. Just won't be so hot for me." And then, having dragged her father's body into the cellar, he returns, having moved beyond what would go under the heading of masculine understatement: "I found a toaster," he tells her, setting it on the counter.

After the killing, neither he nor Holly know quite what to do with themselves. Which is *not* the same as saying they're anguished, or even particularly uncomfortable about what they've done. There's then a fade to black, and a cut to the outside of the house, now in twilight, that's quietly stunning, as we're forced to understand that *that's it*, in terms of notable reactions. *Time passed.* The shooting took place mid-afternoon. Apparently nothing of significance happened—in terms of thoughts, speech, or actions—for the next *three or four hours.*

As the rest of the world has discovered to its distress since the end of the Cold War, it's a cherished American notion that American idiosyncrasy needs to be indulged. It takes all kinds to make a world. Especially an American world. As Holly's father says to Kit when Kit comes to talk to him the first time, and when Kit

refuses to accept that he can't see Holly, "You're something." To which Kit replies, "Takes all kinds, sir."

At the very end, having given himself up, Kit asks the state policeman guarding him in the airplane that's transporting him to death row where he might be able to get a hat like the state policeman has. The state policeman echoes the sentiment Kit has been trying to create wherever he's gone, by whatever means necessary: "You're quite an individual, Kit." And Kit says back, "Think they'll take that into consideration?" It's not just a wiseassed question. Because Kit has already intuited that when it comes to our Western heroes, we do. We have.

Comparing *Badlands* to another young-killers-on-a-spree movie made just six years earlier—Arthur Penn's *Bonnie and Clyde*, considered fearlessly controversial on its release—makes clear just how much before *Badlands* the genre relied on making its protagonists' internal lives open to the viewer, and intensely sympathetic besides. Faye Dunaway and Warren Beatty as Bonnie and Clyde simply will not stop flirting, with each other or with us. They're adorable; what's stressed throughout the movie are the sexual thrills and high-spirited hijinks and excitement that lie ahead, all

embodied nicely in the uptempo banjo riffs that score their various getaway scenes.

Badlands certainly glamorizes the real Stark-weather and Fugate to some extent—the genuine articles were, after all, so demoralizingly depress-ing—but mostly it's interested in deflating those sorts of pleasures described above, or satirizing them. In scene after scene, Kit and Holly seem to prefer each other's company to lying alone in a ditch, or being dead, but it looks like the decision could have gone ei-ther way. There are no high spirits. There is instead a glum sense of things having gone wrong, and a listless sense of not knowing how—or not caring enough—to fix them.

"At this moment I didn't feel shame or fear," Holly tells us in voice-over, right after their eighth murder, while we watch them drive, each gazing out their side of the car, "but just kinda blah, like when you're sit-ting there and all the water's run out of the bathtub." Holly's simile, like so much of her voice-over, is equal parts appalling and flatly comic for what it refuses to register. The image at that moment is equally desul-tory: a two shot of their inexpressive faces, just driving and staring. Equally comic, in an equally dismal way, is the scene preceding that one, in which we see Kit

off behind a boxcar gesticulating to himself his frustration with his own actions after having killed the young couple so like them. We want, in characters like that, Bonnie and Clyde's rebellious sense of their own agency—why *can't* we do what we wish? Why *can't* we break the rules?—so we can live vicariously through them. But Kit and Holly seem to treat what they do as bad breaks, as though they have no more agency in their actions than they would in the weather.

Halfway through we're given, in sepia tones intended to evoke the feel of retrieved documentary footage, a montage of the forces of order gearing up to stop them: a standard part of this kind of movie. Except those forces of order are here mercilessly satirized. We get images of tiny schoolchildren escorted by heavily armed guards; a special detective brought in, apparently in order to point on camera toward the burned-out hulk of Holly's old sofa; American Gothic types posing with their rifles in their new roles as sheriffs of Tombstone; truckloads of trigger-happy Oklahomans cruising around and just itching to let fly.

In fact, one of the movie's more disturbing aspects is how little Kit and Holly *stand out* in their world. Almost no one in the movie seems to express any more emotion than they do, or seems surprised at what they're

doing. Kit's best friend seems unsurprised at being shot by Kit, and willing to chat about his pet spider afterward, while he bleeds to death. The young couple who become the next victims are taken aback, but not much more, at being held at gunpoint. When Kit says to the boy "You expect me to believe that?" about staying put in a storm cellar while Kit and Holly try to get away—a question that has life or death significance for the boy— the boy answers, "Yeah." No one seems to have much of an understanding of their own emotions. During a picnic Kit's best friend laughs uproariously at a joke that doesn't seem to be funny, and then, when Kit asks him, "Isn't that funny?" he sobers up, and says, as though he's not qualified to answer: "I guess." And it seems as though Kit's not the only one who has strange ideas about when the use of violence is appropriate. When her father discovered their relationship, Holly informs us in voice-over, "As punishment for deceiving him, he went and shot my dog." And we watch Oates drawing down on a hapless mutt in the weeds, the poor mutt's ear flapping over in trepidation.

And then there's the inspired touch of having the deputy who actually apprehends Kit—the younger of two policemen—turning out to be a mirror image. He not only resembles Kit ("Hell, he ain't no bigger than I

am," he tells his partner with satisfaction) but, trailing behind as they take him away, the deputy takes aim and fires off into the landscape, absorbed in his own private *Weltschmerz*. A hero is someone who looks like a hero.

The movie's entire visual style reinforces that sense that affect is something happening very far away. (One of the perverse aspects of this essay so far has been how little it's dwelt on the visual, since probably more than any director alive, Malick's thrown in his lot with the visual.) Throughout the movie the cinematography matches the characters' inability to keep their focus on the human. We're given lots of Big Sky long shots; we're given lots of oddly inconsequential backwater bits of nature: a beetle on a stem; muddy water rilling past a sandbar. The effect is the creation of a perceiving sensibility that seems interested in everything and affected by nothing.

But what made *Badlands* truly startling in 1973 was the amount of dissonance it was interested in generating between what we were seeing and what we were hearing. (That dissonance has become more and more overbearing in Malick's later movies, many of which— like *Days of Heaven* and *The Thin Red Line*—are even

more spectacularly beautiful in terms of their cinematography, and feature voice-overs that begin weirdly and then go downhill, ending up vacillating between the tendentious, the pretentious, and the gnomic. In fact, the standard joke in Hollywood about Malick has been that if you're deaf, you think he's the world's greatest filmmaker, and if you're blind, you think he's the worst.) But in *Badlands*, that disconnect between image and sound is always doing intelligent work. Early on in their courtship, such as it is, we cut from a date in town—Kit asking "Can I come around and see you tomorrow?" and Holly answering "Okay"—to a cow's head, its eye goggling out at us. And as her voice-over picks up the narration of their progressing relationship—"Little by little we fell in love," etc.—we see Kit's job in the feed lot: the violence and invasiveness of the work of trapping cattle and forcing their supplements on them. We stay with *those* images while Holly continues her narrative: "He said that I was grand, though," she tells us, while we see him kicking a cow's head during feeding. "He said he'd never met a 15-year-old girl who behaved more like a grown-up and wasn't all giggly," she continues, while the camera lingers over a sick cow that's moaning and lying on its side. These are juxtapositions hard to categorize as

simple irony. This is a use of sound, and editing, to reinforce what the cinematography is up to: the establishment of an agenda that doesn't seem to prioritize human beings.

The dissonance that people remember the most vividly from the movie, though, involves Carl Orff's music, the eloquent use of which has been ripped off pretty much continuously since, most egregiously in Tony Scott's *True Romance*, yet another kids-on-the-run saga. There's a reason it's been poached so many times. The main piece, entitled "Musica Poetica," has a headlong simplicity to its xylophone runs that beautifully evokes a pastoral innocence and childlike play. All of which is incongruous, to say the least, with the general mayhem.

And speaking of innocence: *Badlands* as it proceeds becomes more and more interested in another of our preoccupations, in terms of our self-image as Americans: our insistence upon our essential innocence. Part of the reason we've been willing to accept being stereotyped as not very sophisticated is because of the way *unsophisticated* nestles right up against *innocence*. Think about our conception of ourselves, in terms of our foreign policy: we may screw up, we may

blunder about, but we always mean well. Any harm done to others is either unforeseen or couldn't have been avoided. Our hearts are in the right place, even if we act as though they aren't. That's quite a claim, when you think about it: our hearts are in the right place, *even if* we act as though they aren't.

And one of the smartest and subtlest aspects of *Badlands* is just how slyly Holly's voice-over throughout the movie plays to that desire we have for ourselves.

As she narrates her travels across the upper midwest with Kit, her voice-over begins to become quietly and unobtrusively exculpatory. We slowly realize that there's another reason her voice-over is seeming dissonant from what we're seeing: she's constructing a story that will serve to *distance* her from her beloved Kit, for purposes of punishment.

Which is exactly what happens. She begins the movie by asserting her own childlike innocence— there I was, just a girl playing with my dog—and her family's history of emotional deprivation: How'd I end up in this spot? Well, I came from a sad family background. And then, a surprising number of times, she returns to the assertion that *she* did relatively little ("The whole time the only thing I did wrong was throwing out my fish.") She stages little moments of

epiphany—of dawning understanding—well into their trip. (After Kit has killed his seventh, eighth, and ninth victims, she announces, with a kind of stagy rectitude, in voice-over, "Suddenly I was thrown into a state of shock. Kit was the most trigger-happy person I'd ever met." She turns out to be directly unreliable multiple times, and that unreliability always has to do with issues that might exonerate her or their behavior. She tells us Kit had heard the bounty hunters that he ambushed whispering about the reward money, and that otherwise he never would have shot them, assuming them to be lawmen. But we were *with* Kit during that scene and heard no such thing. Later, for a day or two, they appropriate a rich man's house to hide out in relative comfort, and Holly leaves Kit there, to take a walk. She tells us, while we see her walking farther and farther from the house, "The day was quiet and serene, but I didn't notice, for I was deep in thought, and not even thinking about how to slip off." Thereby raising and answering—seemingly innocently—the question that the law would be most likely to ask: Why *didn't* you run away when you had the chance?

She's also careful to play up the innocents-who've-lit-out-for-the-territory angle. While they're out in the wilderness, we're struck by the continual choice of

visual subjects—close-ups of leaves or bugs, etc.—that seem to constitute a five-year-old's view of nature. We watch all sorts of *Swiss Family Robinson*–type projects underway and hear from her about all sorts of childish plans: building tunnels, adopting passwords. We see them do shy little parallel dances to Mickey & Sylvia's "Love Is Strange." We finally tilt down across a shot of them asleep in their tree house, the camera movement ending once we've been reminded that these innocent children still have big guns. And then we're given one more image of their childhood play turning lethal, as we see Kit testing a basketball-sized swinging booby trap studded with sharpened stakes. *Love Is Strange*, all right.

Holly's self-presentation *works*, it turns out. At the end of the movie we're told that unlike Kit, who got the death penalty, she got off "with probation and a lot of nasty looks." And there's the persistent hint that that's not just the way things worked out; that some of it might have been *engineered*. She also mentions that, oh, by the way, she ended up marrying the son of the lawyer who defended her.

Her self-consciousness as author of her own story is made explicit when she pokes through her dad's stereopticon images while out in the wilderness. "It hit

me that I was just this little girl," she tells us, and goes on to add that "it sent a chill down my spine, and I thought: Where would I be this very moment if Kit had never met me? Or killed anybody?"

She's not only musing about the way she *can* revise her life; she's musing about the way she *will* revise it. "What's the man I'll marry going to look like?" she goes on to speculate. Because she's already got a new life in mind. One that's going to restore a different Holly altogether.

It makes perfect sense that, in an interview after the movie's release, Malick listed as his literary inspirations for her voice-over the *Nancy Drew* mysteries, *Huckleberry Finn*, and *The Swiss Family Robinson*.

It's as if at such moments we're in the presence of a satiric vision that's oddly sympathetic with the myths it's exploding. Part of the reason for that comes from the triangulation formed between the voice-over and the images and us. We have to put the two together. We're conscious of the work of doing so. The third point of the triangle becomes our evolving idea of the movie's position. The visuals alone wouldn't provide that position, and neither would the voice-over.

She helps exaggerate the notoriety they achieve, a kind of listless and amoral celebrityhood of the sort

we all recognize but that in the early '70s was just emerging in force. "The whole country was out looking for us, for who knew where Kit would strike next," she announces, already at work on the legend. And Kit becomes that legend while we watch: hundreds come out to see him, once apprehended, at the airport, and police and bystanders alike seem willing to collect souvenirs he tosses. A father points him out to his little boy. Kit even is granted the satisfaction of hearing the deputy announce that he's a dead ringer for James Dean.

But Holly's story doesn't end with Kit. It's chronicling something else, as well. It turns out that she's working in another American genre that goes back even further than the Western: the captivity narrative. *I have come through the fire—I have come through my harrowing trials—and have emerged at the end, saved.* Captivity narratives, to remind those not as conversant with American colonial literature as they'd like to be, were narratives written by colonists—usually women—spirited away from their homes by savages, women who survived, living among the savages, and then finally were returned to civilization, usually by a raid that killed the savages. Such characters usually had one crucial question to address, implicitly or

explicitly: So just how *did* you survive all this time, exactly? The answer, more often than not, was: I survived because I endured suffering without complaint. I survived because I had an innocence they could not touch. I survived because I was—am—one of the Chosen.

What's initially memorable about *Badlands*' final sequence is Kit's final question—"Think they'll take that into consideration?"—and the unreassuring image that follows of the vast expanse of the sky with its setting sun, as viewed from above the clouds. But what's striking about the sequence if you see it a second time is how absorbed it is with *Holly's* reactions.

"You're quite an individual, Kit," the policeman says, and we get *Holly's* reaction shot, in close-up, to that comment. And her face *isn't* blank; in fact, it looks quietly accused. Kit then makes his comeback—"Think they'll take that into consideration?" and, having said that, looks at *her* (she's facing him in the plane) and we get her reaction shot to *that*. She looks back at him, with a slight, reassuring smile, and then averts her eyes and gazes out the window. And we can see in her expression—in Spacek's performance—traces of both her sadness and guilt.

And then we see what she's looking at: that cloud vista: one last instance in the movie of the sort of lyrical beauty rendered in gorgeous long shot that, like all those Big Sky Country shots that have come before, has an unadorned neutrality to it, partially because of its emptiness and non-human scale.

We *expect* a final comment, a final voice-over, while we take that in. But we don't get one. Instead, we get silence. And then a slightly overly sweet music box lullaby, which winds down as the image fades to black.

Leaving us having been shifted, quietly, from a consideration of Kit to a consideration of Holly. And a consideration of how Holly, in ways we'd prefer not to really examine, has been standing in for us.

THE PIANIST AND SCHINDLER AND THE HERO IN DISGUISE

We seem to cherish the notion about our country that we're slow to get stirred up but decisive once resolved to act. This has been a particularly important part of our national mythology for some years now, given that we're throwing our weight around in all sorts of unlikely places for official reasons that started out as tenuous and have since deteriorated in their persuasiveness. We've now been killing other countries' civilians—without having declared war on those countries—for decades. Our own people have occasionally gotten killed. The mess we claimed to need to clean up has continually gotten bigger. It's reassuring, then, for us to believe that Americans don't rush into things; that we suffer all sorts of indignities to our pride and self-interest before, finally, taking on the

mantle of heroism that had been hanging on that peg waiting for us all along. Imagine George W. Bush recast as young Henry V, for example: the wastrel who'd all along simply been waiting for his country's call to allow him to show everyone just how much he'd been underestimated all along.

In movies this is, of course, one of the central characteristics of the Western hero; of the hard-boiled private dick; of the revenge fantasies that powered the careers of the otherwise-inexplicable Charles Bronson, Chuck Norris, and Steven Seagal, and just about anything lately starring Liam Neeson. This slow-to-rile self-control shows up, in fact, in a surprising number of iterations in our male protagonists.

If you were taxonomizing that figure, you might first divide the type into two basic categories: The Hero in Repose and The Hero in Disguise. Or, say, Henry Fonda in *My Darling Clementine* and Humphrey Bogart in *Casablanca*. Both wait to act. Much of the audience's pleasure, in both cases, derives from that wait and the satisfaction the audience knows is coming. (*Oh, boy, when he finally gets out of that chair . . .*) In the case of The Hero in Disguise, there's the additional pleasure afforded by the anticipated banishment of the movie's not very serious doubts that this person was

a hero at all. No one in *Casablanca*—not the wily and unprincipled Claude Rains, or the absurdly principled Paul Henreid, or the harried and lovesick Ingrid Bergman, or even the poor Nazi straight man (Conrad Veidt, not having come so far, really, from his sleepwalking murderer in *The Cabinet of Dr. Caligari*)—is at all surprised when Bogart's Rick throws self-interest out the window in favor of the underdog and duty. They knew all along, and so did we. Sure: Rick may *talk* like an isolationist for three-quarters of the movie. But when the chips are down . . .

It turns out that the pleasure of watching The Hero in Disguise step forward to assume his responsibility is one of the myriad pleasures expertly generated by Steven Spielberg's *Schindler's List*. And expertly critiqued in Roman Polanski's *The Pianist*. Both are centrally concerned with an ethical question of some interest to Americans right now: at what point someone bearing witness to enormous suffering should attempt intervention, however potentially inconsequential or even futile.

It's impossible to imagine *The Pianist* being made without Spielberg's movie preceding it. Because of the nature of the industry, first of all—who on earth would have handed a director like Polanski 35 million dollars

for such a subject if there hadn't been concrete proof of the possibility of a big payday—but for a more intriguing reason, as well: *The Pianist* seems in all sorts of ways, and especially in the treatment of its central hero, to be a direct response to *Schindler*.

Those who've seen both might notice the odd persistence with which Polanski's movie seems to refer to Spielberg's. Every few minutes in *The Pianist* we come across directly echoed shots and scenes, some of which derive from shared historical sources and some of which seem designed to acknowledge the movie's debt to its predecessor. Spielberg renders the night of the liquidation of the Kraków ghetto through a memorable long shot of the ghetto's windows lighting up with machine gun and shell fire; Polanski repeats the image in his version of the Warsaw Uprising. Spielberg deftly evokes the brutal suddenness of the Polish collapse and German occupation through the economy of his cut from a nightclub party to the drumbeat foot-stomping of storm troopers marching through Kraków; Polanski cuts from his protagonist's father's suggestion that all will be well to those same storm troopers' boots, this time parading through Warsaw.

However much he admired parts of *Schindler's List*, though, aspects of it must have left a director

like Roman Polanski deeply unsettled. One of Spielberg's triumphs was that he'd taken a supposedly unspeakable and unrepresentable piece of history and fashioned it into an enormous critical and commercial success. In doing so, he'd dragged an apparently intractable and hugely forbidding subject into the widest possible swath of public consciousness. Suddenly there was a whole world of people out there who didn't go to depressing movies and who didn't want to learn anything about the Holocaust—because who needed to immerse themselves in something like that?—who trooped into Spielberg's movie, because it was Spielberg and because it was a cultural event, and who found themselves confronting, whether they liked it or not, a pretty effective representation, all things considered, of the liquidation of the Kraków ghetto. For that little bit of forced education alone, Spielberg deserved a lot of credit.

But returning to that notion of the unrepresentable: both the extent and the extremity of the suffering in the Holocaust are so unbelievable that our minds *do*, in fact, turn away from comprehension in the face of them. We never fully grasp that *that* many people were exterminated. Just as we never fully grasp what we're looking at in Alain Resnais's documentary *Night*

and Fog when we're shown the way the concrete ceiling of Auschwitz's gas chamber was *torn into* by human fingernails.

Any commercial filmmaker, faced with material like that—events that may be incommunicable in their own terms—has to use narrative and thematic patterns with some precedent in order to communicate unprecedented meaning.

There was plenty of precedent lying around. The new Israeli state was probably the first to try and find a framework of meaning for the Holocaust by casting it as a cause-and-effect narrative: catastrophe and heroism. There are obvious advantages, in terms of constructing national myths, in connecting the two: catastrophe creates the occasion for heroism; heroism gives meaning to catastrophe. So the industrial extermination of six million people is linked to a historical sequence of Jewish catastrophes, all of which led to the redemptive birth of the Jewish state. Fair enough, we might think. After all, what's the alternative, in terms of making sense of this? Total despair? The implacable hatred of God and man?

Except that choices like that have implications. The creation of a narrative is the creation of an aesthetic object, the design of which generates aesthetic pleasure.

The creation of a narrative *also* demands recognizable, in other words, *privileged*, characters: characters who, for the purposes of the story, are more important than other characters. You see the problem, in ethical terms, of making that claim in the context of the Holocaust.

In fact, as Henry James pointed out, dramatic action almost always revolves around the story of a remarkable character. Which makes the catastrophic/heroic model even more tempting as a way of making sense of the experience. Schindler is heroic. Stern, Schindler's quietly resourceful and ethically flawless right-hand man, is heroic. Pfefferberg, one of the valiant and resourceful smugglers, is heroic. They survive.

We have, in other words, in *Schindler's List* the most traditional kind of narrative structure, based on suspense, based on the questions *missing* from nearly all nonfictional Holocaust texts, from Primo Levi's *Survival in Auschwitz* to Claude Lanzmann's *Shoah*: *What will happen next? Will the good guys survive?* Repeatedly in *Schindler's List* we find ourselves urgently wondering whether a particular character will make it through a particularly horrible event. And repeatedly, our wish is granted, and they do. The stimulation of expectation and the gratification of that expectation is the way commercial narrative structure works.

Everything comes back sooner or later to a satisfying closure. Every family we follow is provided a fate, and every family we follow survives. We're exhilarated, toward the very end, when we see all those faces that we've been following, as the guards read off Schindler's list. It makes us feel—and it's supposed to make us feel—as if Schindler's list redeems all the Nazis' lists.

God knows, Steven Spielberg understands how to produce a pleasurable narrative, and he plugs that expertise into this context. His characteristic moves tend to be scenes of ironic comic reversal. One is the triumph of the plucky underdog, often a child. (So we see a boy in the concentration camp, ordered on pain of death to rat out whoever stole a missing chicken, fingering someone already killed. And, significantly, *not* having his brains blown out for his temerity.) Another characteristic move is the seemingly inexorable disaster averted. (What can possibly stop that great white plowing toward Roy Scheider and his ineffectual little rifle at the end of *Jaws*? Omigod! The oxygen tank in its mouth blew up! What can possibly stop that Tiger tank plowing toward Tom Hanks and his even smaller pistol at the end of *Saving Private Ryan*? Omigod! An air strike!) And what can possibly stop the extermination of all those women whose fates we've

been following once they're herded into the gas chamber and after the doors are closed in our faces—one of the movie's most harrowing moments the first time it's viewed—except: Omigod! It *is* a shower.)

Part of Spielberg's achievement involved knowing when to pull off such reversals and how to mute our impressions of their frequency—since his audience knew the Holocaust to be a story mostly about catastrophe *not* averted. Even so, moves like those must have particularly dismayed Polanski, who witnessed the Final Solution as a boy wandering through Poland, a particularly hellish corner of the European maelstrom at that point, which by all accounts rarely produced the kind of moments we most frequently associate with Spielberg's work.

So in *The Pianist*, other elements from *Schindler's List* are aped in order to be turned inside out, or exposed. There's The Little Girl in the Red Coat, for example, technologically spotlighted and sentimentalized by that theatrical dab of color which, throughout the chaos of the liquidation, makes the pathos of her dilemma even easier to track in long shots. She's literally singled out by her colorization as more heartbreaking, more innocent, first among equals. She certainly seems to strike Schindler that way: when he spots her smudge of red in

a pile of corpses later, it's a moment we're invited to read as decisive in his conversion from selfish to selfless.

A dead ringer for that same little blonde girl pops up in Polanski's movie, and she's accorded no more importance than anyone else. The camera glimpses her alone in the crowded and chaotic resettlement plaza, crying and holding an empty birdcage, and never returns to her again.

One of the more famous moments in *Schindler's List* depicts the capriciousness of both Nazi cruelty and fate: Levertov, an old man, is taken outside the factory to be shot. The officer's gun misfires, and we wait, excruciatingly, while he borrows another; *that* misfires; and finally, the officer gives up, settling for a whack on Levertov's head before moving on. It's the kind of thing *Schindler's List* does so well: a truly horrifying scene, but one that ultimately delivers to us what we want.

So in *The Pianist* a group of Jewish workers are singled out of line, told to lie in the street, and shot in the head one by one. The officer's gun misfires before he can kill the last man in line. He fusses with it and tries again; it still misfires. He fusses with it and tries again, and shoots the man through the head. That moment alone may encapsulate—and may be *intended* to

encapsulate—the difference between Steven Spielberg and Roman Polanski. And may explain, as well, why *Schindler's List* won the Academy Award for Best Picture, and *The Pianist* did not.

The main difference between the two movies, though, involves their protagonists.

In our first real glimpse of Oskar Schindler, played by Liam Neeson, he is seated at a nightclub, cigarette in hand, sizing up the SS men at the neighboring tables, the romantic figure of mystery. Throughout the movie we'll be delighted with Oskar's nerve, and charm, and entertained by his swaggering. We'll stay grateful to him for his ability to continually outwit and stay ahead of the most mythically fearsome figures of the twentieth century—the SS—and their embodiment, Ralph Fiennes's Amon Goeth. (Schindler and Goeth will be organized for us as alter egos: German angel and German devil. At one point we'll crosscut between each of them shaving as they prepare for their day: the day of the liquidation of the ghetto.)

Spielberg's Schindler exudes style and a suavely ironic charm. He seems to be all about jaded self-interest and yet betrays persistent glimmers of warm-heartedness. He's one of those Heroes in Disguise, in other

words, we quickly register, having been raised on the type. Slowly but steadily, more goodness peeks through. So we're encouraged to enjoy and forgive his charming and shallow selfishness, if not exploitativeness, in the first half of the movie—*Jeez. He's hired twenty female assistants, all of whom are beautiful? Are they supposed to be his harem?*—on the grounds that eventually he'll become the traditional hero we want him to be.

Those historical aspects that diminish the real-life Schindler's heroism are muted or eliminated. The real-life Schindler was, apparently, an agent of the Abwehr—German intelligence—which partially explains his nerve, and his miraculous power. That's dropped, which makes his standing up to people seem cheekier and more satisfying. It also allows the audience to avoid mixed feelings as to just what he was up to. Schindler's principal interest to historians has always centered around his ambiguity as a heroic figure; it's never been clear exactly why he did what he did, or how he should ultimately be viewed. The historic Schindler was, clearly, humane. And, clearly, heroic. He also clearly was *hedging his bets*; it did *not* take a genius after Stalingrad to see that Germany was going to lose the war; it was just a matter of when and how. The historical Schindler did most of *his* good deeds in the summer of 1944—*two*

years after Stalingrad began, and *after* the Allied invasion of Europe had already succeeded.

In the movie, though, we're *real* clear on what we're supposed to understand. By its end, Oskar's not only a hero, but a hero who helps, through his individual action, redeem the ugliness of mass genocide, a slaughter organized by one state, abetted by a number of others, and passively accepted by nearly all the rest.

Oskar's heroism is meant to counterbalance, in other words, that much suffering, that much complicity, that much active evil. Opposite all of that on the teeter-totter, this movie sets Oskar. Remember what Stern says to him at the end: "*1,100 people are alive because of you. Look at them. Look at them.*" Which is, of course, the movie's message to us. So the movie has an investment in significantly elevating his stature. Which begins with casting an actor the size of Neeson, who towers over everyone else.

The movie, then, shifts tones between the two modes attendant upon the catastrophic-heroic model: the ironic and the didactically monumental. There's irony all throughout, of course. But there's also a surprising amount of the monumental. There's Oskar in a long shot at the head of all the women he's saved from Auschwitz, like Moses, as he brings them back

to their work camp at Brinnlitz. (The real Oskar apparently sent one of his women to trade sex and jewels for his Jews' lives. That doesn't have quite the grandeur of this version.) This Oskar has so much stature that toward the end, in his last address to the labor camp guards after the war's ended, he dares them in his calm, booming voice to carry out their orders to murder everyone in the camp. His bluff isn't called, and Ben Kingsley's Stern and a few others widen their eyes with relief and admiration, communicating to him and us that he sure is one ballsy guy. Which is very indulgent of them, given that the SS in their experience has never reacted well to that kind of bluff.

Early on in the movie, since Jews can no longer run businesses, Oskar comes to them with a proposition: *he'll* run one: a factory making basic enamelware for the army. *Presentation* is what he announces he can bring to his first deal with the Germans. It's what the deal can't do without. He calls it "a certain panache." It's *not* simply window-dressing, because without it, the deal can't exist. *Without "presentation," the ugliness of the whole thing will collapse the deal.*

Jews put up the capital. Other Jews provide the labor. Stern manages the operation. So then what

exactly, Stern acerbically asks him, does *Oskar* contribute? Well, Oskar answers, not at all embarrassed, he provides the *spectacle*, he provides the *charm*, he provides the *stylishness*. He promotes the hell out of the enterprise. And that's a pretty important task, considering that we're talking about slave labor inside an enforced ghetto that is being slowly liquidated. And we know Oskar can do it, because we've seen him do it before. The purpose of the sequence at the nightclub in which we're introduced to Oskar, in fact, is to take him from unknown to legendary *on the basis of show*, of bluff: from "Who's that?"/ "I don't know," to, as the maitre d' says at the end of the sequence, comically letting us know what Oskar's been up to in terms of reinventing himself in the Germans' minds as someone capable of pulling off a gigantic enterprise, "Why, that's Oskar Schindler!"

Think back to those girls who we dimly register constitute his harem. They *are* being saved by Oskar; they're *also* being exploited by him. Maybe some of them don't mind. Some of them probably do. It's the price of survival. But Oskar's style—his presentation—echoed in *Spielberg's* style—*his* presentation—encourages us to ignore or downplay the sordidness. Spielberg gives those viewers who are alert a chance to

figure things out—we see, for example, Oskar intro-
ducing his girls to the SS officers, so we're allowed, if
we want to pursue the ugliness, to make the analogy
with the baskets of goodies we saw being delivered to
the SS earlier. Presentation: fruit, chocolate, cognac,
women. But the movie is happy to allow *mis*under-
standings on that point, as well. That's how Hollywood
movies work: they simultaneously let us have it both
ways; they let us see things and *not* see things.

Film critic David Thomson was the first to point out
what must have been for Steven Spielberg a grand
analogy between himself and Oskar Schindler: that a
manufacturer of basic enamelware, a man who con-
sidered himself all presentation, might yet save his
soul with "the gift of life." Schindler is dedicated to
presentation and to knockout effects. He's a show-
man; he's elusive at his core; he's hugely successful. He
sounds a lot, in other words, like the way Spielberg
has always been presented in the media. Schindler
in the end proves he's more than shallow; he proves
he's profoundly good. Most importantly, he does so
through his ability as a showman. Oskar Schindler
may have been the first protagonist of Spielberg's
with whom he could closely identify. And Oskar won

him his first Academy Awards, for Best Director and Best Picture.

It's Spielberg's version of Schindler, in other words, who sells the Holocaust to us. It's his version that makes the Holocaust *viable* as a mainstream blockbuster. Most of us will watch the catastrophic *if* we're given the heroic along with it; otherwise we consider it too depressing. And Oskar's deal allows us to foreground the heroic, and the uplifting. He allows the movie to pull off an amazing sleight of hand: to be a feel-good movie about the Holocaust that *still* comes off as unflinching and brave. This is because Oskar *acts*, and acts with near-complete success, even in a situation in which the odds are so overwhelmingly against him. Like all our Heroes in Disguise, he knows what to do, and he does it.

His counterpart in Polanski's *The Pianist* is another historical figure—Władysław Szpilman, celebrated enough for his talent to be a cultural celebrity in his native Poland by the outbreak of the war. As presented to us by Polanski and Adrien Brody, Szpilman is a smoothie: calling out to a friend about a beautiful woman he's just met, "Where've you been hiding her?" as explosions rock their building. (One detonation flattens some

people just behind him on the stairs, yet he continues offscreen in pursuit of an answer, never looking back.) He's incompletely successful at hiding the pleasure his power of celebrity affords him while he's running flirtatious circles around the wide-eyed Dorota, the beautiful blonde who will later, with her husband, provide shelter. He's blasé and slightly foppish, sleek, and finicky in his tastes. There's an odd self-satisfied quality to his gracefulness. His narcissism is, in fact, commented on periodically. Having arrived home safely after the outbreak of hostilities in Warsaw, he tells his brother Henryk, who's fiddling with the radio, that his music show has been taken off the air. As though at the outbreak of World War II, Henryk's major preoccupation with a radio might be in seeing if he can pick up one of his brother's performances.

In the movie's opening scene, Szpilman, in a recording studio, refuses to stop playing despite direct hits on the building and his engineer's departure, until he's blown off his bench by a shell. But the refusal comes across more as a mulish preoccupation with his music than defiance or courage.

So whether we're aware of it or not, we start hoping that he's one of those Heroes in Disguise. For two and a half hours, though, he persistently frustrates that hope.

He's not especially brave, or virtuous. He's a watcher, a reactor, and his recessiveness is one of his most remarkable traits, not only early on, but *even at the end*. He's like a wraith witnessing the ruin of his city and the annihilation of his people. The movie, in fact, continues to make a note of his periodic *refusal* to act, a refusal that, as luck would have it, doesn't cost him. As Warsaw is being attacked, his parents prepare to gather up their family to flee; Szpilman halts all that by announcing that he's not going anywhere; if he's going to die, he'll die in his own home. His statement seems more petulant than intrepid. The same thing happens a few years later, when he's hiding out: his contact arrives breathless and desperate one day to inform him that the Gestapo has broken their little ring and is almost certainly on the way. Again Szpilman says he's not going anywhere. In fact, he stays in that apartment until the building is blown down around him by the Wehrmacht.

Every so often, he teases us with the possibility of a conversion to hero status. He goes to the printer of the underground paper in the Warsaw ghetto and announces he wants to help. The printer tells him with a laugh that musicians don't make good conspirators, and Szpilman drops the subject. Well. *There's* persistence for you. When Majorek, one of the architects of the rebellion, lays

49

out his plans for the uprising—tells him they're about to begin a battle to the death—Szpilman responds, "If you need help, I . . ." and trails off. A few scenes later he finds Majorek asleep on his bunk and whispers that Majorek's got to get him out; he'd rather take his chances on the Polish side than stay there any longer.

To be fair, he's by no means entirely inert. He helps talk his brother out of custody. And for a short while during his last days in the ghetto, he's an active part of the gun-smuggling efforts in preparation for the uprising. But most of the time, he doesn't act or even sound like much of a hero. When one of his Polish benefactors expresses her admiration for the Jews' courage after the failed uprising, he asks her only what good it did, and seems unpersuaded by her answer.

In direct contrast to Oskar Schindler, for nearly the entire movie, Szpilman *doesn't* know what to do, or when to do it.

So how *does* he survive? *Why* does he survive? Luck, mostly. The movie's relentlessly dispassionate tone continually insinuates that survival in the midst of an entire society organized to destroy you requires some mixture of single-minded determination and luck. Heroes, of course, have both. But that's not *all* they have.

One of the quietly radical things about *The Pianist* is just how little its protagonist is allowed to *do*. Mostly, while we watch, he wears down. He hides. We see him sleeping. Fretting. Poking around for food. Trying not to make noise. Staring into space. Every so often he grieves. (Or seems to; it's often hard to tell. He does weep once.)

Mostly, he witnesses things. And yet we need to re-member that part of the point in the early going is that, like most of his compatriot Jews in Poland, he spent a large amount of time during the early war years *in de-nial*. (*Surely the Germans aren't looking to* exterminate *the Jews. And even if they are, surely the Allies wouldn't let that happen*. Etc.) He's a witness because of who he was; he's *also* a witness because this movie is more skeptically self-conscious about its whole enterprise: the whole project of making, and watching, a movie about horrors like this.

Consider how *much* of this movie is viewed through windows. Through windows, from a fixed and limited perspective, the pianist watches these people perish, and history go by. For long, long stretches he's word-less, just gazing upon what's going on. Sometimes he's bored; sometimes he's moved; sometimes he's mesmer-ized; sometimes he has to work to figure out what's go-ing on. Does his position sound familiar? It should.

From their window, the Szpilman family watches the theater of other people's arrests. For convenience, the Germans dump an old man in a wheelchair out the window, then shoot his relatives in the street. Szpilman has a front-row seat for that, and, somewhat implausibly, for both the 1943 ghetto uprising and 1944 Polish uprising. (One apartment turns out to look over the wall into the ghetto, from which he can watch the Jews' increasingly hopeless struggle; another is across the street from Gestapo headquarters, from which he can see the first Polish assaults on their tormentors.)

Both of which leave us and him experiencing a bizarre *You Are There* version of history. Everything, for all its verisimilitude, feels faintly staged. (*Come with us now and witness history from inside the very center of events ...*)

We are continually made at least slightly self-conscious about witnessing. At a street crossing in the ghetto, Jews held up by traffic are forced into a ghastly and impromptu dance by a few bored and playful Nazi soldiers. The sequence, like so many others, with its helplessly restricted vantage point, plays like a circus of horrors viewed by someone shackled to their seat. Yes, yes, yes: the Nazis were sadistic ringmasters. But behind them, of course, as was the case with *Schindler's List*, the filmmaker is the real ringmaster, indulging in

this aggression, theoretically in the service of educa-
tion. And as the coaches of our sports teams never tire
of suggesting to us, the pain that makes us stronger
should not, then, be attributed to sadism.

Both Spielberg and Polanski relied on the documen-
tary footage generated by Nazi filmmakers. As Polanski
remarked in an interview about the footage of the de-
struction of the Warsaw ghetto, "It's easy to forget that
there's someone *behind* the camera, *filming* all of this
horror. Deciding on the most effective or pleasing way
of *presenting* it." And so in his movie we linger on a shot
of a three-man SS camera crew filming Jews; filming us.

There is, in fact, a famous literary antecedent of
active witnessing, even within the Holocaust: Anne
Frank's *The Diary of a Young Girl*. Frank's book became
the ubiquitous school text precisely because of the way
her fierce desire to work through the implications of
what was going on turned the enforced passivity of her
position into something heroic. Anne Frank *didn't* just
sit around all day; she did her best *to work stuff through*,
ethically, philosophically, metaphysically: however she
could. Did Szpilman? We have no idea.

It's important, in terms of our good feelings about
Oskar Schindler, that he not only decisively come
around to the cause of heroism, but that he demonstrate,

in some carefully selected ways, remorse about his earlier self. The historical Schindler stayed matter-of-fact and jovial to the end, according to witnesses. Spielberg, notice, will not allow him that. Spielberg has him break down, a ruined but saved man. And all the Jews he saved, especially the women, surge forward, wrapping their arms around him, to confirm his status not only as hero, but as a hero *who has nothing whatsoever for which to blame himself*. Schindler, meanwhile, is inconsolable, but it's hugely revealing what he's inconsolable *about*. He fixes on his gold Nazi party pin and laments that it might have saved two more Jews. And we think, wait: now he's blaming himself for having spent too much on presentation? But that may be the *only* charge on which the movie has absolutely exonerated him. He only got as far as he *did* on presentation; the movie's been drumming *that* into our heads for three hours.

And what sorts of things is he *not* beating himself up about? How about not having gotten started a little sooner? Or how about the harrowing unfairness of the list itself? Schindler resolves to spend what money he can muster to save as many Jews as he can by buying them back from the SS. Stern, when they're drawing up the list, holds it before him the way, in popular representations of Moses, Moses holds the

tablets, and says, "The list is a complete good." And that's an assertion the movie urgently wants us to accept. The list *is*, in fact, such an awesomely huge good that it's not hard to accept the claim. But a *complete* good? We should give a moment's consideration to the moral ambiguities we're being spared at that point. What would it mean to *draw up* such a list? Imagine: you have great news: you can save a tenth of your family and friends from certain death. Isn't that *great*? Now draw up the list. And now imagine everyone you've had to leave off, after the list's been drawn up, responding only, *The list is a complete good*.

Schindler and Stern draw up the list. Whoever's on it will live; whoever's off it will almost certainly die. No attention is devoted to the difficulty of choosing. Because *we* don't have to choose. Everyone *we've* cared about has made it onto the list. And when those saved hurry to their trains, the camera is careful *not* to pan away to note the less fortunate.

Szpilman, meanwhile, isn't undergoing any conversion experiences, or, most of the time, emoting much of anything. In fact, like two of Polanski's greatest earlier movies, *Repulsion* and *The Tenant*, *The Pianist* slowly turns out to be about being stuck in your own

head and going quietly nuts because of it. Part of its point is to allow us to see this elaborately—and slightly smugly—civilized man reduced to an emaciated animal state. And the pathos in that regard is so intense that it starts to tip into comedy, as when, toward the very end, he hangs on to that oversized can of pickles wherever he goes with all the hopeful credulity of a Beckett tramp, or Charlie Chaplin.

Given what history has chosen to unleash on poor Szpilman, the heroism that's generated derives from the miracle that anything human survives at all. And not from a version of some kind of crucible-created Clark Kent.

While he's surviving, Szpilman is also recording, for us, but *only* recording. As one of the movie's producers, Gene Gutowski, said about him, "The Germans had cameras, but Szpilman *was* a camera."

Well, no matter how taciturn they are, our heroes are not *cameras*. John Wayne's no camera. Gary Cooper's no camera.

And it was exactly that aspect of Szpilman that critics complained about. David Denby in the *New Yorker* groused that the movie didn't attempt "to open up the hero at all. Is he ashamed, defiant, guilty? Grateful for his luck? We haven't a clue. His survival is an anomaly,

a mistake, a joke—and that may be why the story appealed to Polanski." Peter Travers in *Rolling Stone* identified "that we never get inside Szpilman's head" as "the film's nagging flaw. The script, eager to avoid glib posturing, denies the character fullness." The movie, he goes on to conclude, "lacks the heroic heft of *Schindler's List*."

Yes. Exactly.

We don't want to judge Szpilman, and we have no right to. The central question of what makes a survivor, and how one does survive in such a situation, is a question suffused with ambivalence and guilt for the survivor himself. *The Pianist* doesn't even let us take too much refuge in Szpilman's artistry as a source of solace.

What we might call the Matthew Arnold Model of Consolation, applied here, would go something like this: in the heart of this ruined city, on this ruined continent, a German officer playing Beethoven and a Polish Jew playing Chopin keep this tradition of music, this flowering of European culture, alive. Szpilman survives to play music, ergo the humanity of the cultures that created the music is not lost. His art has saved his life, in more ways than one.

All of that seems to be true. But the movie makes the issue of his artistry discomfiting by reminding us

how often he's spared because of his *status* as an artist, as opposed to his art itself. He's treated as though he's more worth saving than others, as something of a special commodity, a special case. He's a point of nationalist pride. Yitzchak, the Jewish policeman who pulls him from the line during the selection, and countless others who help, seem to feel that way. Dorota later tells him while he's hiding out that all sorts of people—in dire straits themselves, of course—have been giving generously to help him.

Some part of those of us who partake in the Arts wants to believe that Rembrandt or Picasso are in some ways more *important* human beings. And *The Pianist* confronts us with the implications of that desire. The publisher of the underground newspaper rejects Szpilman's tentative offer of help by reminding him that he keeps the people's spirits up; he does enough. But we shouldn't forget, either, that the movie never shows us anything like that, and the movie also has his brother Henryk accuse him, instead, of contributing to his people's apathy, and of making his way by playing only for rich parasites.

For a movie that centers on a musician, there's surprisingly very little music used. (It's certainly instructive to compare its soundtrack to *Schindler's*

List's.) Szpilman, alone in one of his hideouts and constrained from making a sound, sits at a piano. We hear the Chopin trapped in his head. It continues while we cut to snow falling outside on the street; then it fades, abruptly. There's some beauty still present. But it's mostly imagined, and truncated. Barely surviving.

The music in his head is all he has to live for, now. It's an amazing thought, when you consider it. When Hosenfeld, the German officer who saves him, first asks him what he does for work, Szpilman says, "I am—I was—a pianist." When he asks what Szpilman will do after the war, Szpilman answers that he'll play the piano.

Part of what discomfits us about Szpilman is that before, during, and after the war he's not just an artist devoted to his art; he's also something of a figure for narcissistic isolation, and it's narcissistic isolation that finally underpins voyeurism. Until the end of the war, when Hosenfeld asks him to play, he's alone, observing horrors through windows, hearing music in his head.

If *Schindler's List* provides reassuring fates for all of the characters for whom we've been induced to care, *The Pianist* doesn't provide anyone's but Szpilman's. Even the fate of its German angel, its Oskar Schindler counterpart—Captain Hosenfeld—is handled with a

flat off-handedness. In Spielberg's world, such heroes are given their due: solemnly memorialized by the entire cast, which returns, out of costume and out of character, after the illusion of the main story has ended, to accompany the surviving historical figures—the surviving real people involved—to each set a rock upon Schindler's grave. In Polanski's world, such heroes are swept away. Hosenfeld turns up in a Russian POW camp; he asks a Pole to contact Szpilman; Szpilman returns to the site, a now-empty field. Two title cards then inform us of Hosenfeld's name—which we didn't know until then—and that he died in a POW camp in 1952. Did Szpilman ever do any more to try and save him? We have no idea. He says he did, in his memoir. Polanski does nothing with that claim.

That's not an omission based on a lack of knowledge. It's an omission that reminds us that the Holocaust is a story primarily about the *un*saved. Szpilman means well. He'd like to help. Every so often he even tries to help. But it's all so overwhelming. And part of the reason it's all so overwhelming is that such an enormous number of people did *not* act.

Mostly Szpilman wants to be left alone to do what it is he does. Great artist or not, he's more an image, in other words, of who we are than of who we'd like to be.

The music he heard in his head he performs, at the movie's end, on a concert grand with a full orchestra. He's alive; civilization's alive; those survivals are miraculous. The movie ends as the members of the audience rise to give him a standing ovation. The final sound we hear is the applause of an audience that's so grateful to finally hear this music, an audience of which we are also members. It's as though his life has come full circle. It's as though he'll carry on as if unchanged by everything that's gone before.

NO REGRETS:
GoodFellas and American Hardball

"The American experience so often is grief disguised as plenitude."

—W. S. Di Piero

Early on in Harold Ramis's *Analyze This*, mob boss Robert De Niro's trusted old *consigliere* trots out a complaint we've heard before from movie mobsters: things aren't what they used to be; there's no honor any more among thieves. That movie's popularity was based on an unexamined weirdness: that the spectacularly paradoxical, if not incoherent, character that De Niro played—the murderous Don with the secret heart of gold—is an accepted type, and has been since Francis Ford Coppola's *The Godfather* and *The Godfather Part II* helped create a portrait of organized crime that's now a rock-solid part of our popular culture. In both *Godfathers*, family and loyalty—the unshakable solidarity of the group—are valued above all else. And of course, one of the thematic hints deployed regularly throughout

the two movies, which made them seem so cheekily subversive, was the parallel they were willing to draw between the Corleone family and corporate culture. Audiences thrilled at the sheer irreverence of it: were the Tattaglias *really* no different from United Fruit?

Well, as we look around us in despair at a clutch of carrion-eaters in charge of our political and corporate landscape who appear positively ebullient in their rapacity, and who appear more and more openly and shamelessly to understand that now, finally, in ways only dreamed about before, the gloves can *really come off*, it seems clear that the most accurate cinematic template for our new political and corporate culture is not *The Godfather*, or even Oliver Stone's *Wall Street*—jeez, it turns out that *some* of those people think *greed is good*—but Martin Scorsese's *GoodFellas*. Maybe nowhere else in American movies can we find such a paradigmatic version of high-spirited and lethally destructive fuck-you selfishness—*a selfishness that may well register, without concern, its own long-term non-viability*—or such a portrait of the way the perpetrators of such selfishness expect the rest of us to be charmed by their good fortune. "It was more that Henry was *enterprising*. That he and the guys were making a few bucks hustling, while other men were sitting on their asses

waiting for handouts," Karen, Henry Hill's wife tells us, by way of explaining why her husband felt justified in bending a few rules, and in the process sounding like she's been attending cocktail parties at Enron. Or Halliburton. Or the Texas legislature.

When it first came out in 1990, *GoodFellas* was read by more than one critic, in fact, as an indictment of some of the worst excesses of Reaganism. But boy, if it seemed oddly relevant then, it seems drop-dead accurate now.

One of the implicit—and, for an audience, intensely pleasurable—propositions of the *Godfather* series was that surgically controlled violence as a means to an end was not only possible but desirable, and that the massive accumulation of wealth by a few of the *good* bad guys was all right, since, after all, it would also benefit some of those innocents dependent on the good bad guys. Vito Corleone muscled in on the local hood running his neighborhood so that his kids would have their shot at the American dream. His son Michael justified his decision that he needed a third of Cuba apparently for the same reason.

GoodFellas works with a kind of pitiless comprehensiveness to demolish such propositions. If you make your living through violence, it repeatedly demonstrates,

you are *not* being strong for your family. You are almost certainly ensuring the destruction *of* your family. Because what you're unleashing in one realm is going to have ramifications in the other. This is a dramatic irony that *The Sopranos* lifted from *GoodFellas*, along with a fair portion of the film's supporting cast.

There are few movie-going pleasures as bracing as an epic that gives you everything you want while allowing you to pretend that it's been delivering hard truths. We can call that the Oskar Schindler Rule, if you'd like. The Academy Awards seem to have been established to honor those bitter-covered sugar pills. And how many movies have pulled off that sleight of hand as well, or had as much of an impact doing it, as *The Godfather* and *The Godfather II*?

Of course, there's a basic unfairness to such a claim. All movies deliver pleasure and lots of it, or they're out of business. And *The Godfather* is no more interested in history than *Macbeth* is. And it certainly delivers more strong medicine than, say, *Ben-Hur*. But the series also hit on a marketing strategy that the Republican party has since mastered: embedding the expected Concern for Values within a reverence for nostalgia while, with the other hand, steamrolling whatever traditions get in the way of a buck. The *Godfather*s insistently cast

a rosy glow backward, claiming the real tragedy to be not gangsterism but the way gangsterism lost its family values. (This is made explicit in the first *Godfather*: other ethnic groups and their agendas, such as drugs, we're told, sapped the honor out of running a crime family.) In *The Godfather II*, Robert Duvall as Tom Hagen, the Corleones' rock-ribbed *consigliere*, compares them to the Roman Empire, and our understanding of the family's history mirrors the traditional view of the Empire, which romanticizes the early days of the Republic and laments the later decay of moral fiber in Imperial Rome. What we're encouraged to overlook in that formulation, of course, is the fact that if you got in *either* Rome's way—and even, sometimes, if you didn't—you got steamrolled.

The insistent theme of the series is the deterioration of values presided over by Al Pacino's Michael Corleones'. In *II*, Michael's America in the late '50s is contrasted with the halcyon days of his young father, Vito, a role of such laconic and steely-eyed rectitude that it won De Niro his first Academy Award. Vito occasionally killed people, but only arrogant and cruel oppressors we didn't mind seeing killed. In *those* days you could kill and be a family man. *Then* there were values.

Back then in gangster families, fathers were doting, mothers were faithful and uncomplaining, followers were almost always loyal and good-natured, and violence and family values were easy to compartmentalize. For Vito, going home again to Sicily involved avenging his mother's murder by filleting the local Don and then taking his family to Mass in the Don's little village. Neither act affected the other in the slightest. None of the locals even seemed disturbed at the morning's assassination.

Like *Patton*, which Coppola also wrote, *The Godfather*s lure us in with their protagonists' heroic qualities, but feel like more than hagiography—feel bracing and adult—because they remind us of their protagonists' more problematic activities. Still, the heroic qualities are always arranged to overshadow the problematic. It's a view of organized crime so evidently appealing that it's rarely been challenged, at least not by other movies looking to make equally large pots of money.

One of the first to seriously do so was Scorsese's *GoodFellas*, based on Nicholas Pileggi's book about real-life mobster Henry Hill. Most of the mobsters Scorsese knew *loved* the *Godfather* movies. Henry Hill loved them. When Scorsese asked why, Hill told him, "You know; they're like King Arthur and the Round

Table." His analogy hit the nail on the head, in terms of the power of the legend: that's most people's only version of medieval British history. *If ever I would leave you, it wouldn't be in summer* . . .

Well, if *The Godfather* is *Camelot*, *GoodFellas* is *Monty Python and the Holy Grail* with periodic ass-kickings. (Early on in the latter, John Cleese asks Eric Idle why he assumed Graham Chapman to be a king, and Idle answers, "He's hasn't got shit all over 'im.")

GoodFellas doesn't make dignified the nature of such a business. Which is not to say it doesn't demonstrate its *appeal*. It *is* to say, though, that it makes the *nature* of that appeal a little more unpleasantly clear.

Think of the difference in the way the by-now obligatory scene of the godfather receiving petitions is handled. Michael and Vito Corleone tend toward formal wear, which has a real retro-*GQ* look in the rich mahogany gloom of their stately offices. Paulie—Paul Sorvino—in *GoodFellas* crowds his crappy TV tray with his sausage sandwich in his chain-link-fenced backyard. Paulie's movie may convey the visceral buzz of the wiseguy's life, but it *also* conveys the minginess of such spiritual bankruptcy, and the toll. We remember the way Henry, and Karen, and *everybody*, look by the end.

Its most relentless agenda, though, is to demytholo-
gize the connections, the loyalties, supposedly inherent
in such a business. Jimmy and Tommy, Robert De Niro
and Joe Pesci's characters, will do anything for Henry,
Ray Liotta's character. *And* they'd kill him at the drop of
a hat. In fact, the movie is *structured* by betrayals, as we
alternate between bonds being celebrated and violated.
There's a long track across the head table holding all
the wiseguys during Henry's wedding. They're having
a great time, livin' the life. And by the end, thoughtful
moviegoers will realize, *every single male* at that table
besides Paulie and Jimmy have been killed by Paulie or
Jimmy. Henry tells us proudly that wiseguys had a lot of
principles they lived by, but the one greatest principle
by far was: never rat on your friends. And he rats on his
friends. And while he's doing so, he's not even remotely
sorry he's selling them out.

Is he *sorry* for the wreck of his life? Is he sorry
for all of the killing he's been a part of? After every-
thing has disintegrated, his main regret is that the
Party Down part of his life is over. Even as we see his
life-long pals Jimmy and Paulie standing up in court
to receive their sentences, Henry's voice over has al-
ready forgotten them, in his celebration of how much
he had: "We had it all just for the asking. Our wives,

mothers, kids, everybody rode along. I had paper bags filled with jewelry stashed in the kitchen and a sugar bowl full of coke next to the bed. Anything I wanted was a phone call away."

It's Scorsese's portrait of Hill's shamelessness and invincible inability to be educated in ethical terms that's turned out to be so prescient about where we are headed as a country. In just one week around the time I wrote this essay, we were treated to, just to choose a random sampling, Paul Wolfowitz, the US Deputy Secretary of Defense, remarking in *Vanity Fair* that disarming Iraq's weapons of mass destruction was nothing more than a "bureaucratic reason" for war; Donald Rumsfeld, when asked at a press conference just what had happened to all of those weapons, suggesting with a straight face that maybe Saddam had gotten rid of them all before we arrived; and someone named Michael Ledeen, who apparently held the Freedom Scholar chair at the American Enterprise Institute, going on record to announce that "Every ten years or so the United States needs to pick up some crappy little country and throw it against the wall, just to show the world we mean business." More examples blossom forth in backwater areas of the media every single day. Their message is the same as the wiseguys' message in *GoodFellas*: *Are we lying? Of*

course we're lying. And guess what? You're going to sit there and take it.

Because the people making those claims believe they know what the wiseguys know—what Thucydides reported to us the Athenians knew, when dictating terms: that "The question of justice arises only between parties equal in strength, and that the strong do what they can, and the weak submit."

The strong do what they can, and the weak submit. We can get behind that, if the strong are working for us. Which they are, they're quick to point out. So we share this shamelessness with them. One week after the powers that be announced the Iraqi war to be over, the EPA reported that the average fuel economy of America's cars and trucks had fallen to its lowest level in *twenty-two years*. No one around me looked embarrassed. Polls, for what they're worth, demonstrated that the American public never *did* get clear why we were supposed to be invading Iraq. What the Bush administration discovered, to its delight and possible relief, was that it didn't matter.

In the *Godfather* series, corruption is something that involves a lot of grand, operatic turning points. Poor Diane Keaton, as Kay, Michael's wife, in *Godfather II*

has to deliver lines like these: "At this moment, I feel no love for you at all. I never thought that would happen, but it has."

In *GoodFellas*, corruption is more sordid and deflating than dramatic. Everyone goes about their business, which is taking care of themselves. Very late in the movie we register that Karen, Henry's wife, is using cocaine big-time. It's news to us. We never even saw her habit start.

Corruption in *GoodFellas* is so pervasive and banal that it's simultaneously dismal and funny. Karen reminds Henry before he leaves for a hard day's work that she needs money. He asks how much, and she moves her forefinger and thumb as far apart as she can and says, "This much." When he balks at the amount, she drops out of the frame to convince him. We hear his zipper lowered, and Henry, his hands still up in the air, holding money, goes, "Oh, *all* right."

Part of the wiseguys' appeal is inseparable from what makes them so appalling. They don't fret or waffle around; they *act*. They know what they want, and they can sum it up in one word: *more*. Not just money and power; they *have* those. Halfway through the movie they pull off the Lufthansa heist, a six-million-dollar score. And why aren't they satisfied after that? Because they

want more. It's precisely that rapacity, that appetite, that makes them who they are; that allows them to recognize themselves. There *is* no end. There are only means. There's no end point if you're perpetrating the kind of fraud that disintegrated Enron; there are only way stations of accumulation and deception. You go from one to the other, and keep moving. That's the ethic on display in our foreign policy, as well: let's get things *moving* a little. Take down Afghanistan. Take down Iraq. I don't like the look of Syria, either. And what's up with Iran?

Scorsese's wiseguys pay some lip service to the notion that they're doing this for somebody else—for their families—but, as Henry points out to us more than once, part of the exquisite joy of the life is that they really don't have to care about anything else. Especially when they're having a good time and making money—which, they try to see to it, is nearly all the time. At bottom, they don't give a shit about wives, kids, mistresses, or, when it comes right down to it, each other.

And for all its in-your-face flamboyance, the movie is systematic in the understated way it reminds us that, by the way: *kids* live in their world. After a savage fight between Henry and Karen about his going to see his mistress, we're given a shot of, and then slow zoom in on, their little daughter in the hallway, listening. After

a close-up of Karen ringing his mistress's apartment buzzer and calling her a "fucking whore," we cut to discover that her kids are *with* her. During visiting day in jail, while Karen throws around the drugs and food she's smuggled in for Henry, upset that his mistress has visited, the framing doesn't forget either of their little girls: one's crying while the other just looks on, stupefied.

And by the way: What are those little girls' names? Henry never bothers to tell us.

The effect of the lifestyle is a leveling of moral proportion, a flattening nicely embodied in Henry's last day before his big bust, when he's trying to do everything at once: fix his tomato sauce, sell some guns, package his drugs, etc.

Which brings us back to violence. It's what's at the heart of the wiseguys' appeal. *They* don't waffle around; they *act*. And that usually involves somebody getting hurt.

Both Coppola and Scorsese are categorized as directors fascinated by violence. But it's helpful to think about how differently they use it.

One of the basic organizing principles of the *Godfather* series is the controlled organization of its violence, that operatic gathering of tension generated by a lot of systematic crosscutting, often between at least three

locations. The sequence from *The Godfather II* involving young Vito Corleone's first murder is a typical example. In the middle of a pageant in Little Italy, we alternate, in subtly accelerating rhythms, between details of the pageant itself; the evil Don, making his way back to his apartment through the crowd; and Vito, working his way toward him. The music of the pageant—a march— becomes Vito's theme music, the music of the intrepid adventurer, as he leaps from one rooftop to another. The excessive crosscutting not only generates suspense; it also *overprepares* us for the violence, and by extending the delay, makes the violence itself all the more cinematically satisfying.

As is often the case in Coppola's work, the culmination of the violence is not quite what we expect—it turns out, disconcertingly, that Vito shoots the man in the *cheek*, and that the towel with which he swaddled the gun as a silencer catches fire—in order to make everything feel a little more spontaneous. But the actual *onset* of violence could not be more carefully anticipated.

And once he's back on the stoop, having completed his task, he snuggles with his family, his young wife and toddlers arrayed around him, and murmurs, "Michael, your father loves you very much. Very much." So. Do we think what just happened was justified?

Well, the movie's going to help us along, if we're having trouble deciding. There's also someone with a guitar on the stoop—you know, it's one of those pastoral, ethnic-neighborhood moments—playing *the theme of the movie*: the *Godfather* theme. Little Sonny and little Michael squirm around, their future assured. The melting pot, in operation: some little fish rise up. Others may have to go under.

Compare that to probably the most famous scene from *GoodFellas*. Joe Pesci's Tommy is telling stories in a bar and making everybody laugh. Henry tells him he's funny. Tommy asks for a clarification of what Henry means. And we first come to realize that Henry's in trouble, that the situation may have changed, because of the silence that falls as Tommy starts his questioning. Before we even register that the background noise has stopped, we feel the difference. Horror films use sound the same way.

And Pesci himself usually plays Tommy as all gesture and sound effect, so that when he *stops*, the effect is startling. These guys are all *about* noise. And when they stop being about noise, we notice.

The scene's a little primer on the nature of the violence in that world. Sometimes the violence is comic, sometimes it's frightening, and sometimes it's both,

but nobody's very sure which category they're confronting. And the movie continually demonstrates the consequences of those kinds of blurred distinctions: a guy getting a bottle in the face is funny, nothing to worry about, as is shooting the foot of a kid who's too slow to bring you drinks, and then when the kid makes you feel uncomfortable, and shows some *resentment* over being shot in the foot, you kill him. And what does De Niro's character *say*, having seen the kid shot, after having egged Pesci's character on? "I was only *kidding around* with you." Jeez. How could anyone tell? *We* certainly couldn't. As Pesci's character says to another guy while they're giving each other grief, and just before he stomps him (literally) to death: "I don't know. Sometimes it doesn't sound like you're kiddin.'"

With these guys, violence may not happen when we think it will. And can happen whenever we relax. That's part of what's so disconcerting the first time we see the "You think I'm funny?" scene: We're with Henry, and Henry's our surrogate, so we thought we were safe. We thought this show was for us. We hadn't expected it could *turn* on us. We hadn't expected our spectacle to have danger in it. We hadn't expected hanging around killers to be unsettling. We like to know when we're

safe and when we're not, and *GoodFellas* refuses us that comfort. Henry shouts, after waking up to find Karen holding a gun to his head: "In my own *house*, I gotta worry about this?"

The design makes us live with the wiseguy's inability to draw moral distinctions. Henry explains for us the ironclad, unshakable foundation of their world: "If you got out of line, you got whacked. But sometimes, even if people didn't get out of line, they got whacked." The movie's littered with the corpses of guys who *thought* they were in a movie called *The Godfather* but wised up a little too late. We're like them: we were enjoying this ride with Henry, and then we were ready to get off, but we were in deeper and associated with people a little more unpleasant than we realized. And the movie makes us pay for our complicity and enjoyment.

And it *was* a heck of a ride. Scorsese uses a moving camera with as much joy and eloquence as any living director, and we're given in *GoodFellas* three Steadicam tours. (The Steadicam being a lightweight, gyroscopically balanced body rig that allows the camera to go just about anywhere.) The first, a tour of Paulie's cellar, serves as a comic deflation of the rhetoric of the Great Old Days; the second, of a bar, serves as an introduction

to most of the secondary wiseguys; and the third is a dazzling backdoor entry to the Copacabana. Those tours, because of the seductiveness of the camera movement itself, serve as a floor show of sorts—for Henry, and for us. The exuberance of the filmmaking is part of what makes us feel so viscerally how seductive this kind of wiseguy energy and lifestyle can be. The Copacabana sequence evokes just how impressive Henry was to Karen: it demonstrates for us the kind of entry into a dizzying world that she describes to us in voice-over. And it enacts the ethic of the wiseguy: do a little backdoor maneuvering, go around the schnooks who wait in line. Henry's power unfolds before us: doors open, everyone recognizes him, everything parts before him effortlessly. Swept along by *that* camera movement, Henry is *exactly* what he claims to be: a movie star with muscle. The muscle is provided by Martin Scorsese and Michael Ballhaus's camera. The wiseguys show off and play the same way the movie shows off and plays, and as their audience, we play with them, completing their work for them by assuming the role of the schnooks who are open-mouthed at what they're up to.

And the final resting point of all that movement reminds us that it's all about the means, not ends; reminds us of the small-time nature of these triumphs. This is not

a moment when a crime boss is being outmaneuvered. All of that energy and payola and virtuoso camerawork and what-have-you has gone into what? Getting Henry a table in front of Henny Youngman.

GoodFellas is designed as a crazed amusement park ride through the underworld, a ride that accelerates, and then accelerates again, before finally breaking down. The first hour tracks a maniacally high-spirited rise to power, but a rise to power that *began* with a brutal killing. Then the movie cycles back to that killing: the one that finally eliminated for Henry any last illusions about the wiseguys' "code." The victim hadn't done anything; what's more, he was one of them; and what's more, he was an elite version of one of them: *a made guy*. The movie's entire second hour is devoted to a downward slide toward the day of their arrest. And the final thirty minutes are an extended coda of revenge, betrayal, and collapse.

At the end of *The Godfather II*, loyalties are also breaking down. Michael Corleone's murder of his main rival (who used to be one of his father's closest allies), the voluntary suicide of his loyal lieutenant, and the murder of his hapless and betraying brother are all

presented as heavy burdens for Michael to bear. They *also*, however, become the occasion for a memory, a flashback that summons nearly the entire cast from the first *Godfather*. The original effect is now hard to recreate, but for sheer, crowd-pleasing brio, it's hard to imagine a more brilliant stroke. Precisely when the movie seems bleakest, it provides the audience with its deepest desire: a return to the old days, before everything deteriorated. The audience hadn't seen James Caan as Sonny, Michael's older brother, since he'd been murdered early in the first movie. Other old faces—Here's Tessio! Here's Carlo!—are resurrected as well. And after those surprises the movie even hints at the *ultimate* surprise—a return appearance by Marlon Brando!

(The occasion of the flashback is old Vito's surprise birthday party. The tease about Brando's possible reappearance extends even to his daughter's offscreen exclamation, "He's here!")

Before Vito's arrival, though, the argument at the dinner table between his sons reveals where Michael initially went astray. Sonny tells him, "Your country ain't your *blood*; remember that." Vito comes home; everyone else goes off camera to celebrate. We dissolve from Michael alone and still at the table to

Michael as a baby with his father on the train in Sicily (after his father has just pulled off that high-wire murder-someone-and-then-go-to-Mass stunt), and we dissolve from *that* to the famous image of Michael alone at Tahoe, wearing black, sitting in a chair, grimly aware of his moral decline. We track slowly into a monumental close-up of him while that lushly romantic *Godfather* theme overwhelms our ability to resist. Fade to black.

The tragedy *The Godfather* offers us depends on our understanding that Michael could have been the man that Vito imagined in his rosiest plans: the upright and idealistic Senator Corleone, or Governor Corleone. But *The Godfather* itself reminded us—*Michael* reminded us, when he reminded Kay—that those men themselves were often killers and criminals. Vito offers us, in other words, a belief that his own movie *itself* demolishes, and such is the power of his movie's ability to have it both ways that we can register that information and *still* shake our heads in sadness at what might have been: poor Michael.

GoodFellas has no patience for concluding gestures that smack of the poignant. It ends with Henry disabusing us of the notion of the tragically wrong turn.

Henry, in the process of ratting out his friends, addresses us directly, trying for the last time to get through our thick heads that he *doesn't* regret having chosen that life, but only regrets being *like us*, people for whom he has only contempt. Our last image of him is as a dull homeowner in the witness protection program, picking up the morning paper and looking at us as if the nasty joke is that his status as our mirror image is the worst punishment of all. Earlier in the movie he'd let us know what he thought of people like us: "Those goody-good people who worked shitty jobs for bum paychecks and took the subways to work everyday and worried about their bills were *dead*." And that's where he's ended up: an "average nobody who has to live the rest of his life like a schnook."

It isn't a coincidence that Henry and his pals' spirits are highest during the '50s and early '60s, that the watershed turn takes place at the beginning of the '70s, and that the crash comes in the '80s. His timeline invites us to read the movie as a history of postwar American consumer culture, a reading that Scorsese confirmed when he said in interviews that really, the movie is all about money. (And we remember how *often* money itself is a central image, whether it's close-ups of fat rolls of bills changing hands at Christmas, or of all those

envelopes with presidents peeking through the oval windows at Henry and Karen's wedding. During the latter image we hear someone murmur, "*So beautiful.*") The movie, when it came out, certainly hit *some* kind of nerve. That it's a critique of something more than just the underworld seemed confirmed by the fact that Warner Bros., excited by the movie's obvious narrative appeal and star power, thought initially that it would try it as a mass release, and previewed it in the wealthy suburb of Sherman Oaks, California. Whereupon the preview audience reacted with such outrage that the studio was forced to scotch the idea.

Before the movie finishes—with Henry shutting the door in our face—we're given another glimpse of what he'll never forget, and what *we* were most fascinated by: Tommy, the most dangerous and unstable wiseguy of them all, back from the dead and calmly pointing a gun at our faces. He acts out Henry's contempt and aggression in the wiseguys' *real* language, and reminds us for one last time the way Henry recalls, without any remorse, the life that's now gone. He's done what he's done and he'd do it again. And if we don't like it, that's tough shit.

And what better emblem for the American dream gone toxic could Scorsese have chosen than punk

rocker Sid Vicious's musical vandalizing of "My Way?" It's a caustic reference to *The Godfather*'s sly use of Frank Sinatra in its fictionalized subplot about Johnny Fontane, since "My Way" was the song that came to symbolize Sinatra's romanticized climb from a poor Italian kid in Hoboken to the top of the heap. "My Way" became the show biz anthem of self-congratulation: I *did* it, and I *did* it *my* way. That was the dream of achievement and self-realization on behalf of his sons that Vito would have said all of the killing was *for*. But it was always especially for Michael. Fredo was the weak one; Sonny was the wild one; Michael was the one for whom Vito—and we—could have hopes. Sid Vicious's life and death were calculated to be an insult to everything celebrated in Sinatra's song. Consider what a sneering commentary the song seems to *be* on those final images in *The Godfather II* of Michael Corleone, brooding in magnificent CU. "*Regrets*," Sid Vicious brays. "I've had a *few* . . ."

Part of what gave figures like Dick Cheney and Donald Rumsfeld their beltway appeal was the unembarrassed aura they projected that they *had* done bad things and would do them again. They cultivated that same sort of pornographic don't-fuck-with-me, I'm-the-guy-who-bombed-Cambodia appeal that Henry

Kissinger has enjoyed all these years. It *worked* for them. It made them the closest thing that the right had, at that point, to actual warrior heroes. That was not an unimportant point, because their stature derived not from having fought in a war, but from having projected a bracing, I-never-gave-it-a-second-thought species of ruthlessness. Coppola's Vito Corleone was deeply sad about the life he'd made for his family. Michael Corleone was steely-eyed in his resolve but, we were assured, secretly tormented and bereft in the end. Scorsese's Henry Hill made clear in every way he could that remorse or second thoughts were for other people. No hair shirts for him. Instead he collaborated on a self-celebrating memoir (though not a memoir as grotesquely self-celebrating as the three Henry Kissinger has written), before returning to drug-dealing. He set up a website for mob buffs, including a feature called Whack of the Week.

And we're the schnooks who gape and give these people our grudging or not-so-grudging admiration. We're the schlemiels who shrug and think to ourselves, *Well, at least they get things done.*

LAWRENCE, AGUIRRE, AND THE AMERICAN IMPERIAL MOMENT

By the third scene of David Lean's *Lawrence of Arabia*, its hero, a radiant and impossibly blue-eyed Peter O'Toole, has already begun to enjoy his precocious and nearly inexplicable success at something he spends the 1962 movie's three and a half hours doing: talking people into accepting his version of the world, a version that, on the face of it, seems absurd and untenable. Lean's movie, in the grand tradition of Oscar-winning Hollywood blockbusters, takes a few liberties with the historical record. His protagonist, when we first encounter him, is a minor staff functionary whose main attribute seems to be an odd intensity, an intensity deployed with uncanny effectiveness to convert spectacularly skeptical, xenophobic, and battle-hardened warrior chieftains from an entirely foreign culture to his geopolitical vision.

How does he do it? That's, of course, part of what we, the audience, are meant to be pleasurably wondering. We're given a few clues—O'Toole *is* at that point in his life probably the most beautiful man on the face of the earth, after all—but scene after scene seems constructed to communicate to us that the main reason he's so persuasive is that he's just so *sure*. Over and over again, the movie stages scenes of British or Arabic befuddlement at Lawrence's disconcerting sincerity.

Twenty minutes into a 216 minute pageant dedicated to supporting the Great Man theory of history, we find Lawrence in the Arabian desert, having talked his bemused superiors into letting him have a go at winning over various tribes of legendary wariness and recalcitrance to the cause of the British Empire. We see him beginning the process of doing so not by the logic of his argumentation but through the force of his personality. Arab after Arab is converted not by what he says but by who he is. And who is he? He is someone who, when all others would lose faith in themselves, refuses to lose faith in himself.

Lawrence's plan—Lawrence's vision—is, we're assured by all the experts with whom he comes into contact, somewhere between quixotic and certifiably insane. But

then—as George W. Bush suggested to interviewer Tim Russert during an appearance on *Meet the Press*, mostly through the amiable inflexibility with which his assurance rolled through any doubt created by the growing numbers of contradictory facts—part of what it means to have an indefatigably imperial vision of one's place in the world, of course, is to have a somewhat vexed relationship with what the rest of us call reality.

That's what makes for visionary leaders, whether they're the sort who attempt to construct an pan-Arabic alliance behind a British agenda, or a thousand-year Reich.

Lawrence's superior officer remarks about his insouciant insubordination—his way of behaving as though he *has* no superior officers—"I can't make out whether you're bloody bad-mannered or just half-witted." "I have the same problem, sir," Lawrence replies. When asked how on earth he's going to pull off the impossible, given that he doesn't even seem able to perform his basic duties as a staff functionary, he answers, "I cannot fiddle, but I can make a great state from a little city." The quote's from Themistocles, he points out helpfully. For Lawrence, as for George W. Bush, his lack of aptitude for nearly everything seemed to be part of what convinced him of his

greatness: he clearly wasn't made for ordinary tasks. So perhaps he was made for *extraordinary* tasks.

Off Lawrence goes into the desert, with his camel and his initially skeptical Bedouin guide, two little dots against the 70 mm wide-screen immensity of the Arabian desert, creeping along as if huddled together under the crashing grandeur of Maurice Jarre's famous theme music/score. It takes him three minutes of screen time to convert the guide completely.

On a camel in heroic medium shot, he's told that here he may drink. But when he sees that his guide is not drinking, he resolves to drink only when the Bedouin does. Making camp, the Bedouin asks incredulously, "Truly, now, you *are* a British officer?" And then asks if Britain is a desert country. No, Lawrence tells him. A fat country. "*You* are not fat?" the Bedouin asks. "No," Lawrence says simply. "I'm different."

By the time that sequence is over, even the dimmest sort of filmgoer knows what kind of genre he's in. He's in the land of Epic Adventure. Part of the reason Maurice Jarre's score won the Academy Award, and has become the gold standard for film composers for communicating Epic Grandeur, is its success at signalling viscerally not only majesty, but majesty *put to use*; majesty *mastered*. It's all about not only the

96

exhilarating pleasures of exploration, but of *imperial* exploration.

What's the agenda behind a movie like *Lawrence of Arabia*? Why *was* Lawrence such a great guy, according to such movies? Why do we like him?

Partly because of where he took us and what he showed us. Lawrence and his movie tell us in the grandest possible way: stick with us and we'll give you the kind of stunning eye candy that only the movies can deliver. And: stick with us and you'll be learning something about other cultures and places. But of course, there's a difference between Lawrence and an anthropologist. David Lean wouldn't have made a dime with a movie called *Lawrence the Anthropologist*. We love Lawrence not only because he took us somewhere, but also because when he did, he allowed us to enact the pleasure of gaining *mastery* over it. While we watch, fiercely recalcitrant Arabs fall in line. Mostly unlikeable Turks die. Skeptical British officers look on with growing admiration. And the implacable, unconquerable desert is continually maneuvered, and vanquished. (*No* one can cross a particularly fearsome stretch called the Sun's Anvil, we're told by the Bedouins. Lawrence does it twice.)

Werner Herzog's *Aguirre, the Wrath of God*, made ten years later in 1972, seems very much to be in conversation with David Lean's movie. Once again we open with otherworldly beauty, and an otherworldly sense of scale. Following some intertitles explaining that after the plundering of the Incan Empire by Spain, the Indians invented the legend of El Dorado, the land of gold, and that in 1560 an expedition led initially by Pizarro set off after it, we're confronted with an extreme long shot of a tiny line of figures making their way along an impossibly sheer track leading down through the clouds. But we've already been flatly informed that this imperial adventuring is harder to euphemize (they're after gold, and that's all there is to it), and the music cueing our appetite for what's coming couldn't be more different. Instead of orchestral triumphalism we're getting the unsettling weirdness of Popol Vuh: a band consisting mostly of a single German musician named Florian Fricke recording and overlaying mournful parallel tracks of recorded voices and electronic organ. The effect is instantly haunting and elegiac: the opposite of the boys-in-the-barracks sort of rouser we'd expect to begin an Epic Adventure. It's as though things have already gone, or could only go, south from here. As though the sadness of all that's going to flow from this undertaking is already built in.

We watch, stupefied, at the hubristic lunacy of this as an undertaking. The endlessly Sisyphean nature of such a trek is brought home to us when the conquistadors come climbing unexpectedly back *up* into the immediate foreground of the frame. Oh, God, the viewer thinks: they're not just going down *this* impossible cliff; they're going up and down *many* such cliffs.

They're dragging along in their wake the entire iconography of the Spanish conquest, an iconography becoming more surreal as it parades past the camera: halberds; rifles; a noblewoman's chair, on a litter; the lady herself, dressed pristinely, as if back in Castile; cannon wheels; the Virgin Mary. And finally, the always-arresting Klaus Kinski as Aguirre, instantly identifiable—through his malevolent wariness and preemptory stage-managing of the marching order— as balefully monomaniacal.

And when it comes to a subject like the balefully monomaniacal, you're not going to find a filmmaker more qualified than Werner Herzog.

Herzog has always been the sort of guy who, if you're a film critic, you might call a maverick, and if you're a district attorney, you might call a criminal. When he was fourteen he sent ideas for film projects to German producers, who thought at one point that

they had a real deal working, until they met their director face to face. It's a measure of his monomania that he was surprised they were upset. Since no one was willing to fund him at the age of fourteen, he went back to high school and worked nights as a welder to fund the production of shorts he then sent around to festivals. The shorts won prizes, but no money, which meant he still couldn't afford a 35 mm camera, so he stole one from a film school in Munich. *Aguirre* was shot with it. He said by way of explanation that he didn't consider what he'd done theft; he considered it necessity. He had a natural *right* to a camera.

Cinematically, what's immediately most striking about Herzog's style is the arresting and continually unstable divide between the obviously stylized and what looks like an obsessive commitment to realism. *Aguirre*, like the rest of his movies, alternates between a sloppy chaos that feels documentary-like and highly stylized still lifes. Cinéma-vérité stuff— like bumping around on a pitching raft on a choppy and rainswept river, spray spotting the lens—is juxtaposed with the weirdly aestheticized, and the startlingly static: long takes of telephoto shots of roiling rapids. Baby mice rooting around at the bottom of an overlooked nest.

Probably unsurprisingly, Herzog has always made both documentaries and fiction films, and sometimes it's been a little hard to tell the difference. Anyone who's seen one of his movies knows how weird his basic strategy for moviemaking really is: he's mostly interested in rendering mysterious internal emotional states. And he's mostly interested in getting *at* those states *through the visual contemplation of something else.* What's going *on* in Aguirre's head, or the Spaniards' heads? What's it like to *be* them? He tries to show us by showing us what they're looking *at.* Or, more precisely: *how* they're seeing.

Sometimes that impulse seems to require realism (here we are on the raft, shoulder to shoulder with our compatriots, bumping around and getting wet); sometimes it seems to require something else: some version of expressionism (here we are gazing at the washing-machine turmoil of one small area of rapids for a full twenty seconds).

The difference between realism and expressionism, in epistemological terms, is usually summarized colloquially as follows: the world as it is versus the world as someone sees it. Herzog's movies and style are all about fuzzing that border. Partially because the monomaniacs who interest him are always fuzzing the border themselves, in order to remake their worlds.

From the very beginning, even Herzog's documentaries were concerned with the internal and the ineffable: what *couldn't* be recorded on film. That's part of what won him so much attention. He made a documentary called *Land of Silence and Darkness* about a blind and deaf woman, and *in* that documentary attempted to recreate her way of experiencing the world. Think about that: in movies you have two things to work with, essentially: the visual image, and sound. Herzog decided he wanted to use the *visual image* and *sound* to get at what it's like to be *blind* and *deaf*. In another documentary, *The Great Ecstasy of the Sculptor Steiner*, he described his main agenda as the rendering of a ski jumper's sensation of weightlessness. In one called *La Soufrière*, he tried to document not a volcanic catastrophe but the *anticipation* of one: the experience of feeling as though you're *about* to experience one.

That sort of dedication to expressionistic concerns helped form a bridge between Herzog's work and the first great golden age of German filmmaking in the teens and twenties. In fact, his movies not only *recalled* those movies; they sometimes *remade* them, as in the case of his reiteration of F.W. Murnau's *Nosferatu*.

And he himself is an expressionist figure. This is a guy who said about his home, a farm in a remote part

of Bavaria, that he remembered "only a deep ravine and a mystical waterfall." A guy who described one of his movies as being about a chicken in a cardboard box. And then he added, "Chickens terrify me. I'm the first person to have shown that chickens are cannibalistic and horrifying."

This is a guy who believed sufficiently in the power of will that in 1974, when the great German film critic Lotte Eisner was said to be dying in Paris, he set off on foot *from Munich* to visit her—not only, he said, to pay tribute to her, but to *prevent her death*. She survived until after his arrival.

Given his tendency to act as though the world would accommodate itself to someone of sufficient will, we're not surprised to learn that the stories *behind* the making of his movies are often as amazing as the movies themselves. Those stories are usually characterized by his taking a cast and crew somewhere no one believed a cast and crew could go, with almost no resources and on the basis of mostly chutzpah alone. Which makes, of course, the story of Aguirre the story of Herzog. Which helps explain the intensity of the ambivalence with which Aguirre is viewed.

Herzog's film crews have been lost in Saharan sandstorms, stranded by African floods, beaten in

Greek and Turkish jails, and nearly drowned in Irish seas. Even in countries as innocuous as Holland his shoots have been harrowing for all involved. Shooting *Nosferatu* in a little town outside of Rotterdam, he let loose on his cast and the somewhat surprised locals *eleven thousand* rats, which swarmed over actors, passersby, gawkers, and outnumbered rat wranglers and then disappeared all over town. He later complained, after the uproar, that he didn't know what everyone was so angry about. He'd *had* the rats neutered.

Naturally, then, filming *Aguirre* involved talking 450 cast and crew members into essentially *recreating* some of the most dangerous parts of the historical Aguirre's expedition: climbing down the Andes and then through some of the most inhospitable jungle in the world. (For those opening shots from the precipitous sides of the cliffs, Herzog had to hang from tree branches, because Thomas Mauch, the cinematographer, refused to do it.) They had a total budget of $360,000, an eight-man crew, and a five-week shooting schedule. In other words, no resources and no time. For the scenes on the river they built two makeshift rafts to follow the characters' rafts. The

company slept in hammocks and on planks when ashore, but for two of the five weeks they were unable to *go* ashore because of the flooded jungle. One raft got caught in a whirlpool and started to disintegrate. That's in the movie. As Herzog put it, "That was very unpleasant for the people on board."

They had only the one camera he'd stolen, and everything flowed one way on the river, which meant there'd be no retakes at particular landmarks or points of interest. It also meant that whatever happened, he tried to use it. When one night the river rose fifteen feet and swept their rafts away, Herzog announced that the same misfortune had befallen Aguirre's men and demanded that they start building replacement rafts when he resumed filming the next day. He announced himself King of the Jungle for the duration. (Since he was forced to shoot chronologically, his rule about secondary cast members was this: the biggest troublemakers in camp the previous evening were the first to be killed the following day, and sent home.)

The biggest troublemaker on that set or maybe any other was the mostly demented Klaus Kinski, who played the lead, and who so shared his character's enraged sense of entitlement when it came to remaking

the world that he was stopped by crew members at one point when emptying his rifle at the extras. (He shot the tip off someone's finger.) His boss was equally preemptory when it came to challenges to his authority. When asked if it was true that he only kept Kinski from leaving at one point by holding a gun on him, Herzog answered, "Those stories are exaggerated. The gun was back in my tent. I only *told* him I'd shoot him. But he knew I was serious."

All of which brings us back to Lawrence and his certainty about his role in remaking the world. *Aguirre* is designed in some way as an explicit critique of that monomania, as seen from the inside. Having been sent on an exploratory foray by Pizarro, Aguirre immediately mutinies, shooting the commander Pizarro appointed and demanding his men's fealty. They fall into line partly because of his murderousness and partly because he just seems so sure of what he's doing. The city of gold *does* exist; they should go after it; and it's *definitely* in this direction. His logic is himself. His evidence is himself. He gazes at doubters until the doubters waver. *He* knows. Do *they* know? Even Aguirre's way of moving embodies his radical inflexibility: Herzog strapped Kinski up in crisscrossing leather

harnesses, leaving him bizarrely tilted and stiff, and then directed him to move only like a crab, sideways, and in spirals whenever possible.

George W. Bush, when asked about the absence of weapons of mass destruction that he'd said he had no doubt were present in Iraq, found the question in some ways irrelevant. He answered it, in that same *Meet the Press*, this way:

"That's very important for, I think, the people to understand where I'm coming from. To know that this is a dangerous world. I wish it wasn't. I'm a war president. I make decisions here in the Oval Office in foreign-policy matters with war on my mind. Again, I wish it wasn't true, but it is true. And the American people need to know they got a president who sees the world the way it is. And I see dangers that exist, and it's important for us to deal with them."

This is not an unusual concept for a man of faith: what's real is not what you can touch and see. What's real is what you believe. David Kay or Colin Powell might have been dismayed by their inability to touch or see the promised weapons that justified an invasion. Their president wasn't. He knew what the truth was. The truth was whatever it is he *wanted*. If the facts

didn't coincide with that truth, well, then, at some point, another set of facts probably would.

This is something Americans have come to want in a president: that he says what he believes and he sticks to it.

So: remaking the world requires a new way of seeing, and continuing to see, the world.

For a lot of casual filmgoers, the visual style of a movie like *Aguirre* is itself high-handed and perverse. When we're forced to peer for a full twenty seconds at a telephoto shot of a small stretch of roiling rapids, we're increasingly aware that what we're looking at is devoid of what we'd consider either sufficient human or narrative interest. We think we've grasped what significance there is to the shot—*rapids, right*—and then we *don't* move on.

But Herzog, like Aguirre, and like Lawrence, doesn't care what lesser men (read: just about everyone else) tell him he can or can't do. As far as he's concerned, a radical set of objectives necessitates a radical strategy. And he wants something strange to be happening to narrative at moments like that. Because a movie about monomania is a movie about what special figures *know*, or think they know; *not* what ordinary people would register. Such filmmaking is mesmeric by design. It

mesmerizes us the way the monomaniac mesmerizes himself. Herzog said about *La Soufrière*, his documentary about the anticipation of the volcanic eruption, that "never before were *signals of such magnitude recorded*, yet *nothing* happened." Signals of such magnitude recorded with nothing happening: it's not a bad description of the way Lawrence first experienced the desert. Or the way the neocons experienced Iraq.

There's a scene late in *Aguirre, the Wrath of God* in which the one miserable horse that they've brought along on the raft, ostensibly to shock and awe whatever natives they encounter downstream, finally rebels and starts breaking the raft to pieces. They put it ashore, and shove off, and Herzog holds on a long take of the now-quiet horse, standing on the edge of the bank, surrounded by impenetrable jungle, and steadily watching the people who brought him there—and us—grow farther and farther away. As an image, it's a wonderfully evocative and forlorn critique of the imperial project: those who did the heavy lifting are left behind God knows where. Next case.

Later in the movie, those remaining, still floating downstream, are at the end of their tether. The camera

records a hallucinatory reality on the riverbank—a large ship, one hundred feet up in a tree—without trying to settle or help us negotiate the issue of its existence. What are we supposed to make of it, when we see it? Is it a fever hallucination? One that we all share? That's what this whole project has been. Monomaniacs like Aguirre are, finally, pretending, though pretending on a deep level. At moments like that we're forced to ask ourselves, as filmgoers: At what level *is* the pretending operating? Questions like that can take on a national significance as well. Questions like that are among the most urgent ones we can ask about our governments' foreign and domestic policies.

Aguirre ends with its protagonist stalking around his nearly empty raft, lording over some terrified monkeys. He holds one petrified little monkey in his hand and proclaims himself the Wrath of God before pitching it into the river. He then restates who he is and what he seeks. He finishes by saying, "Who else is with *me*?" And Herzog provides his answer visually, in the next shot: the sun, blinding us, and burning itself into the lens.

ZANE GREY AND THE BORGIAS:
The Third Man and the 2004 Republican Ticket

Probably no more than a thousand American movies examine, mostly without meaning to, our national preoccupation with, and devotion to, the notion of our own innocence. As I mentioned in an earlier essay, when generalizing about ourselves, we have no great investment in the notion of our sophistication, or even our competence. (Though we'd like to believe that we're mostly competent.) We're absolutely unyielding, though, on the subject of our good intentions. Sure, we've been willing to admit mistakes—at least before the Bush administration—as long as everyone understood that we *meant* well. Okay, we concede, we bollox up the occasional intervention, but why? Only because we were trying to help.

And what's better evidence of that, we like to point out, than our attempts to get Europe back on its feet

after World War II? Weren't we right there, wallets open and hands out, ready to help Gunther and Pierre and Guido out of the rubble almost before the shooting stopped? And did we ask anything in return, besides a little cooperation and maybe some gratitude?

Well, yeah, some European movies, like Carol Reed's *The Third Man*, suggest. We did. We do. Even *if* some of our hearts were occasionally in the right place.

Now, I'm one of those people who thinks that there's never a bad time to see *The Third Man*. It is, after all, about as nifty and stylish and endlessly pleasing as thrillers get. But in early 2005, post-inauguration, I found myself with many of my countrymen once again looking forward to four more years of disaster for our refusal to see through a brazenly transparent rogues' gallery. And *The Third Man* offers us a by no means entirely unsympathetic, but nevertheless bracingly clear-eyed, European take on an American type germane to that rogues' gallery, a type broken into its constituent halves. The movie offers us two old friends, Joseph Cotten's Holly Martins and Orson Welles's Harry Lime, abroad in postwar Vienna. Holly and Harry, one the dark side of the other, both wreaking havoc, one obliviously, with an outraged sense of his own virtue, and the other cynically, with a blithely and sinisterly overdeveloped sense

of his own self-interest. And if that sounds familiar to those of us who lived through all eight years of the second Bush administration, it should.

In 1948 producer Alexander Korda sent novelist/ screenwriter Graham Greene to Vienna to research a movie about the postwar occupation of the city. At that point the four powers had divvied it up into zones: American, Russian, British, and French. Everyone was trying to help; everyone was angling for their piece of the pie. It was open season, as far as creative entrepreneurship went. It was an Allied Tower of Babel. It took Greene only two months to deliver the treatment.

His story involves the clueless but sincere Holly Martins, author of dime-novel westerns and out of his depth nearly everywhere. In the first three minutes, Holly arrives in the city to work for his old friend Harry Lime and discovers that Harry's just been killed. An accident, apparently. Except that even Holly can make out some pretty glaring discrepancies with the eyewitnesses' stories, and Calloway, a British officer he meets at Harry's funeral, tells him that Harry was the worst kind of racketeer, and that the world's better off without him. Well, now, hold on one minute. There may be something shady about his pal's death? And now

European-types are trying to impugn his pal's reputation? What would *The Lone Rider of Mystery Gulch* do in such a situation? That's a no-brainer. Holly decides to get to the bottom of this: the lone sheriff come to town. He doesn't know the city at all and doesn't speak German. Or Russian. Or French. But he's on the side of right. And that's enough for him.

Joseph Cotten's Holly Martins is your basic red-state heartland kind of guy. He has rock-solid values, all of which he's decided to leave unexamined. He has a covert pride in his own mulishness. He believes that the inflexibility of his loyalties ennobles him. His version of *My country, right or wrong* is *My Harry, right or wrong.* He's suspicious of sophistication and, for a guy who's *on the case*, oddly disinterested in learning much about where he is. He assumes that the frontier virtues on display in his paperbacks will cut right through any foreign equivocating, dithering, and/or obstruction. He decides what's best for the leading lady without having bothered to learn almost anything about her. He barges in on everybody, mispronouncing names. He's the portrait of callowness, and cluelessness, but he still means to get the job done. And it never occurs to him that his being in over his head might be dangerous for *other people.*

Holly's an essentially decent guy, played by an essentially decent guy—production notes record Cotten spending some of his free time while on location handing out food parcels to Austrian orphans in the American sector—but he's wandered into a sort of placid but lethal hornets' nest. Carol Reed renders the movie's opening voice-over with the mordant distractedness of someone swindling on one person while chatting with someone else. We're told that the wide-open opportunities Vienna afforded at that point, "in the classic period of the black market," attracted lots of amateurs, but, "well, you know: they can't stay the course like a professional." To illustrate the point, we're allowed to gaze upon a lumpish figure floating facedown in the Danube.

Sure enough, Harry's Viennese friends, when they're interviewed by Holly, seem to embody your basic xenophobic Republican's fantasy of Euro-perfidy, like they're the UN version of the Seven Deadly Sins. Each face is a little cameo of craftiness, greed, duplicity, or smiling malice. Ernst Deutsch as "Baron" Kurtz is half Joel Grey, half Joseph Goebbels, all saturnine smiles and baleful sympathy. He wears a Rosalind Russell fur collar and carries a whimpering and unpleasant miniature pinscher that just can't be as small as it

117

appears. His expressions of sincerity would generate skeptical contempt in Gomer Pyle.

Erich Ponto, meanwhile, as Dr. Winkel (Holly: "Dr. Winkel?" Winkel: "*Vin*kel." Holly: "Dr. Winkel?" Winkel: "*Vin*kel."), comes across as an unpleasant mix of Ernest Thesiger—remember Dr. Pretorious, the flamboyant old queen with the basset hound face from *The Bride of Frankenstein*?—and Joe Lieberman. Mostly he stands around projecting *I don't release information*. And Siegfried Breuer's Popescu is all oily, smirking, insincere courtliness. ("I helped Harry fix her papers, Mr. Martins. Not the sort of thing I should confess to a stranger, but you have to break the rules sometimes. Humanity is a duty.")

It turns out that Harry's friends are also the only eyewitnesses to Harry's demise. His personal driver was driving the truck that hit him. His doctor and best friend, who happened to be passing by, were the only ones who attended him.

It's all enough to make Holly suspicious. You don't have to conk *him* on the head with a plank to get a point across.

This whole *place*, in fact, he notes with some distaste, is a little off. Certainly we note it, too. To begin with, it even *sounds* off. Mention *The Third Man* to

most people who've seen it and the first thing they remember is its musical score. Fair enough: it is one of the very few movies scored entirely by a single instrument: Anton Karas's whiny and peppy and tinny little zither, which provides throughout an inappropriately merry, Devil's Carnival–like counterpoint and satiric edge. (Reed apparently discovered both Karas and his instrument at the party welcoming his production company to Vienna. Helpful note to would-be filmmakers: going the zither route makes for a soundtrack that's in turns playful, stylishly overdramatic, and parodic.)

The Third Man is also invariably remembered for its camera angles, which are so flamboyantly and insistently canted in crucial scenes that director William Wyler, a pillar of by-the-book and blandly handsome American filmmaking, famously gave Reed a carpenter's level when he saw him after the movie came out. Streets plunge diagonally out of the frame, cathedral fronts pitch and yaw, and even shot-reverse-shot exchanges tilt the characters toward and away from one another. But all those vertiginous angles aren't just Reed's version of *look, ma, no hands* filmmaking; they also set off just how four-square and upright our Holly, abroad in a land of shifty relativists and dirty dealers, imagines himself to be. They continually make the

wry and faintly menacing visual point that this isn't a world of straight-arrows. Or *for* straight-arrows.

The American hero doesn't just get to the bottom of things, though; in that case, Harry being dead and all, there'd be no one around to be properly grateful; no one in whose admiring regard the taciturn and modest hero could subsequently bask. Someone needs to be *rescued*, as well. Holly settles on Harry's girlfriend.

She's the logical choice. She's a woman, isn't she? And pretty? And she looked sad at the funeral. And she's certainly a more presentable locus for all of those fascinated feelings Holly has, or had, for Harry.

Except that Alida Valli's Anna Schmidt, in her first scene with Holly, exhibits all of the winsome and virginal charm of a late model Marlene Dietrich. She's sexy enough, in an end-of-Weimar kind of way, but she's not going to qualify as anyone's damsel in distress. Holly asks her if she was in love with Harry, and she answers like she's Old Tired Europe herself: "I don't know; how can you know a thing like that, afterwards? I don't know anything anymore except I'd like to be dead, too. Some more tea?" Holly, a little oblivious to nuance, is charmed by this, and comes away from their meeting determined to be her knight-errant.

She loved Harry. She says this repeatedly, with the kind of affect you might employ to announce that your socks are wet. When she returns to Harry's apartment with Holly so that Holly can attempt to grill the porter, an eyewitness to the accident, she doesn't quite display the emotional turmoil we'd expect from all of these memories flooding back. While Holly futilely tries to make himself understood, she plays with Harry's cigarette lighter. She wanders around appraisingly. She combs her hair in his mirror. She rolls dice she finds on the bedside table.

"Well, if I *do* find out something, can I look you up again?" Holly asks her, after the interview with the porter hasn't gone so well, the porter clamming up and throwing him out. Her response couldn't be more encouraging: "Why don't you leave this town? Go home." He's unfazed. He escorts her to her apartment, where they walk in on Calloway and the Allied police midway through a search for information on Harry's racket. And here's some good news: while they watch, Calloway sniffs out her forged passport. Calloway and his adjutant hold it up to the light; they proclaim it very good work; they take it away from her, and tell her she'll have to come down to the station. "Anything really wrong with your papers?" Holly asks, always three steps behind.

It's Holly's goofy and misplaced longing, based on a narcissistic self-regard, intersecting with Anna's dismay and disdain that gives the movie its overall tone of dry doomsday humor and erotic melancholy. Vienna becomes a city of romance in which romance is doomed, a city that's gotten to the point in which romance is beside the point.

So far, his return on all of his efforts has either been deflating or demoralizing. Naturally, he resolves, then, to act even more decisively. He runs his scenario of what happened by Calloway, who tells him it sounds like a cheap novelette. "I *write* cheap novelettes," Holly says, indignant and hurt.

More action on his part is problematic, given that he's invincibly gifted at misreading the situation. He invests the banal with the terrifying ("Have you got orders to kill me?" he shouts at a taxi driver who's speeding him to a speech about which he's forgotten) but blandly ignores gathering menace. (Anna has to drag him away from an increasingly ominous crowd in the street outside the murdered porter's home, after the porter's gnome-like son fingers him as the last person to have seen the victim alive.) Just about every major character he encounters tells him that he's in over his head and that his methods are sure to backfire. Even a

parrot he passes bites him. "This isn't Santa Fe, I'm not a sheriff, and you aren't a cowboy," Calloway explains. "Haven't you done enough for tonight?" Anna asks, with ever-increasing fatigue.

But he's not entirely unteachable. Calloway, at the end of his rope in terms of trying to control Holly's blind-man-in-a-lightbulb-store explorations around town, finally decides to give him a little seminar on the blackness of Harry's soul. He makes Holly sit through a magic lantern show of everything they have on his friend. It's pretty harrowing stuff. Harry was stealing penicillin from the military hospitals, diluting it to make it go further, and then selling it to patients, with catastrophic results for the patients. Calloway stresses in particular the impact on the children suffering from meningitis. The lucky ones, he tells us, died.

When the show's over, Holly's desolate in his disillusionment. "How could he have done it?" he asks himself as much as Calloway. "Seventy pounds a tube," Calloway shrugs, and recommends he go back to the hotel and keep out of trouble.

But that's not really Holly's thing. He gets drunk, buys an absurd bouquet (mums?), and wakes up Anna in her apartment. "HL" is embroidered on the pajamas under her robe. He swans around, self-pitying,

and announces he's going. "It's what you've always wanted," he mopes. "All of you." He's not very clear on much, except his adolescent sense that No One Wants Him Around. Anna looks at him as if she's at a loss as to how to make that same point any clearer.

But now that the cat's out of the bag—now that Holly and we are sure that Harry was no good—it's time to resurrect him. "I knew him for twenty years, or at least I thought I knew him," Holly says morosely. "I suppose he was laughing at fools like us all the time."

And outside Anna's apartment, in one of the more famous moments in film history—celebrated, among other places, in Walker Percy's *The Moviegoer*—Harry's cat ("He only liked Harry," Anna tells us) pads along the dark cobblestoned street to a pair of wingtips in an unlit doorway. He nestles in against the man's ankles; he peers up; he nuzzles a shoelace. Holly, meanwhile, continues his brooding until Anna interrupts, "Oh, please; for heaven's sake, stop making him in your image. Harry was real. He wasn't just your friend." "I know, I'm just a hack writer who drinks too much and falls in love with girls," Holly tells her, and then peeks up. She looks at him. Two kinds of solipsizing; two kinds of self-pity. He'll try one and then the other.

Leaving, he scuffs his way home. He hears a noise in that doorway; sees the cat. "What kind of a spy do *you* think you are, satchel-foot?" he calls across the street, drunkenly pleased to have found someone in Vienna clumsier than him. Satchel-foot doesn't move. The cat keeps cleaning itself. Holly keeps calling and taunting until an upstairs neighbor's light goes on, illuminating Harry's face. Harry's bemused, then amused. An eyebrow goes up, as Orson Welles does his roguish charm thing.

Harry Lime, Welles told Peter Bogdanovich, was what you called a Star Part. A Star Part was one of those roles in which you only show up late in the movie, but the entire cast talks incessantly about you for an hour until you appear. By then, your charisma has been so predetermined, you only have to do a few minor things and you come off as riveting.

So. Holly chases Harry; Harry disappears, magically; Holly informs Calloway; Calloway instantly figures out where Harry has gone: the sewers. Holly, meanwhile, returns to Harry's friends, tells them to summon Harry and that he'll be waiting at the Ferris wheel. Harry warily strides up via the roundabout route, scouting out any potential backstabbing, has a go at a backslapping re-union (Holly won't take his hand), and they go for a ride.

Inside the Ferris wheel compartment, the two halves of that American type confront one another. "Listen, Harry, I didn't believe that—" "It's good to see you, Holly," Harry says, cutting the formulation short with patronizing affection. He complains of indigestion. Holly tells him Anna's in trouble. "Ah, that's tough, that's tough," Harry concedes. "They're handing her over to the Russians," Holly adds, to give his anxiety some force. "What can *I* do, old man? I'm *dead*, aren't I?" "Holly," Harry says, sucking an antacid and cutting to the chase, "exactly who did you tell about me? Hmm?"

"You don't care anything at *all* about Anna, do you?" Holly demands. You can almost feel him thinking, We're *Americans*. We're all *about* altruism. "Well, I've got quite a lot on my mind," Harry chuckles. Turns out *Harry* told the Russians about Anna, to further endear himself to his protectors. When Holly rants around about his disgust, Harry reminds him: "I've never cut you out of anything."

Holly asks if Harry's ever *seen* any of his victims, and Harry answers, bringing back to mind the glory days of Dick Cheney hardball: "Victims? Don't be melodramatic." He throws open the door of the car. They're at the top of the wheel. "Look down there.

Would you really feel any pity if one of those . . . dots stopped moving, forever? If I offered you twenty thousand pounds for every . . . dot that stopped moving, would you really, old man, tell me to keep my money? Or would you calculate how many dots you could afford to spare? Free of income tax, old man; free of income tax." Holly looks on, *unsurprised*.

"It's the only way you can save money nowadays," Harry adds.

Harry is that bouncing American boy, now just about everywhere in the Bush administration, who sees the world as a source of plunder. As Greene describes him in the novella he wrote afterward based on his treatment, he features "big shoulders that are a little hunched, a belly that has known too much good food for too long, and on his face, a look of cheerful rascality, a geniality, a recognition that his happiness will make the world's day."

Holly and Harry make not only an unsettling portrait of the second Bush administration's president and vice president, abroad to help and to make a little something on the side; they also, as a pair, clarify just how much one exposes something central in the other. *The Third Man* turns out to be the story of a typical American's refusal to believe that good old Harry—genial,

cheerful Harry—has an unexpectedly pitiless interior. It's Harry's *ruthlessness* that Holly has so much trouble believing, and Holly refuses to believe—despite all the evidence—at his own peril. As, right now, do we.

Harry's simply acting the way governments act, he points out to Holly. "They have their five-year plans; so do I."

There's something irresistibly attractive, stunningly enough, about that kind of certitude about one's own values. Harry's out for Harry, and never made any bones about it; that's caused everyone to shrug and shake their heads and admire him for his childlike appetite and relentless drive to service his own desire. "He never grew up," Anna shrugs, thinking back on her boy. "The world grew up around him. That's all." Later, having herself confronted the reality of all those victimized children, she still won't renounce him entirely: "I don't want to see him or hear him. But he's still a part of me; that's a fact."

And a part of Holly. At first he agrees to betray Harry to Calloway in order to rescue Anna—about to be deported to the Russian Zone—but then botches the selflessness of that gesture because he can't refrain from having her glimpse his self-sacrificing heroism at the train station as she's leaving. She rejects her role,

gets off the train, and tears into him. Feeling chastened in matters of loyalty, he returns to Calloway and announces that the deal's off: Calloway can run Harry to earth himself. Calloway assures him that he will. Holly says, "Well, *I* won't have helped." Calloway points out that "That'll be a fine boast to make."

So sly Calloway, driving Holly to the airport, stops by to drop in on those victims he told Holly about before. Holly, not figuring out what's happening, tags along. Stunned, he peers into crib after crib at all sorts of silent suffering we can't see while Karas's mournful little zither vamps. He's re-resolved. The betrayal—the split—is back on.

Anna storms in on Holly, the bait waiting at a cafe. "You can't tell me you're doing all this for nothing," she says witheringly. "What's your price this time? Honest, sensible, sober, *harmless* Holly Martins," she says bitterly, putting the stress on exactly the right word.

Harry's warned by their exchange, but not warned soon enough; after a prolonged chase, he's cornered in the sewer's spiral staircase. Having been shot by Calloway, he's finished off by Holly. Before Holly does so, they exchange looks, and the suffering Harry seems to mutely plead to be put out of his misery. It's as if Hyde is pleading with Jekyll.

Which brings us to the coda of Harry's second funeral. Anna's back, as is Calloway, as is Holly. Holly's sad, of course, but also oddly hopeful, when it comes to Anna. After all, he's purged his dark side, hasn't he? He asks Calloway to stop the jeep carrying him away from the grave and let him out so that he can wait for Anna, walking along the lane. "Be sensible, Martins," Calloway says, his last words in the movie encapsulating his exasperated advice throughout. "I haven't got a sensible name, Calloway," Holly answers. I yam what I yam, as Popeye puts it. The zither does a stirring if slightly mournful little fandango. Holly leans against a cart and waits for the distant Anna. The romanticism of his own self-image is too fundamentally ingrained to have been broken by the events of the last few days; he's going to wait there, for Anna to arrive, in order to enact the happy ending. A few leaves fall. He waits and waits, as do we, while in an extraordinary long take, Anna walks toward him and us down a corridor of trees so severely pruned they look blasted. When she finally comes level with him, that happy ending he was hoping for evaporates. Her face makes clear that she has no more patience whatsoever with either the tenacity or the primacy of his illusions about himself. She just keeps on walking, past him and us.

BABETTE'S FEAST
AND THE WEEPIE

As a kid back in the Pleistocene, I was periodically dumped in front of the TV after school, and that meant either talk shows, soaps, or movies, and every so often I'd tumble out of a run of rubber-suited monster pictures—*Reptilicus*, *Gorgo*, *Night of the Blood Beast*—into another equally bizarre afternoon genre: the "woman's picture," or "weepie," as *Variety* called them.

We recognize the territory when we channel surf into it: Lana Turner in that enameled '50s technicolor, facing away from some knit-browed and forgettable male; Barbara Stanwyck looking star-crossed and miserable as she peers over a fence in the rain at her own daughter's wedding; Joan Fontaine just *staying put*, her whole gestalt a perfect figure for submissiveness. An overstated string section to help us register the heartache.

The stories trundled through decades of forbearance: slow-moving mile-long freight trains of self-denial. All those women gave up what they most wanted for somebody else's sake. Which meant their movies centered on events that didn't happen: the singing career that wasn't begun, the wedding that didn't occur, the meeting in the park that never came off, the key phrase left unspoken. Which made for movies obsessed with the life *not* lived: a weird negative space of the never-was and the might-have-been. Even the titles gave it away: *Written on the Wind, All I Desire, Since You Went Away, There's Always Tomorrow, Imitation of Life*.

This genre received some public reconsideration in 2003 because of Todd Haynes's *Far from Heaven*, with its four Academy Award nominations and critical support on both coasts. While *Heaven* was not as jaw-droppingly mechanical a project as Gus Van Sant's shot-for-shot remake of *Psycho* a few years before, the debate around it centered on just what to make of the extremity of its stylistic self-consciousness. It was either a reconstruction of or a paean to Douglas Sirk's movies, particularly *All That Heaven Allows*, and Sirk was the great master of the astoundingly overwrought and the weirdly bottled up when it came to American suburban white emotions.

We still gape today at such movies partly because of the way they enshrine what seems to us an antiquated masochistic selflessness, if not self-eradication. They all seem to feature a woman who wants in some way to express herself, to make herself known, plopped down in a story that demonstrates the impossibility of realizing that desire. Again, go back to the titles: *Letter from an Unknown Woman*, *The Old Maid*, *Madame X*.

All of that should sound familiar to anyone who's read one of those steamer trunk–sized 18th-century novels, like Samuel Richardson's *Clarissa,* that feature 1,500 pages of private feelings informed by pious, if not puritan, codes of morality and conscience colliding with innermost desires. Conflicts, in other words, not so much between heart and head as heart and *soul*.

If *that* was the choice, it wasn't too hard to figure out which we were supposed to root for. Jeez. Heart (and by implication, body) or soul: Which was ultimately more important? In other words, even by then, desire had become the mechanical rabbit powering the race but always a little ahead of the greyhounds: the thing it was okay to want as long as you understood you should never get it.

All those critics enlisting *Far from Heaven* for their Ten Best lists, then, had a problem: how to celebrate a

movie that seemed to offer such unappetizing or out-dated thematic dichotomies. Those who didn't like the movie considered it a kind of patronizing anthropology: *boy, were people dumb back then*. Those who liked it tended to solve the problem by assuming some sort of irony or camp was in operation: that *Heaven* was a parody, even if a loving and reverent parody.

This, of course, is a dangerous strategy for celebration, since it mostly evacuates the work's ability to move us. So Daniel Mendelsohn led the charge to recuperate a greater seriousness for movies like Haynes's in an essay in the *New York Times Magazine*, "The Melodramatic Moment." Mendelsohn's move was to suggest that the cultural ground had shifted significantly enough that classic melodrama—a larger category than weepies alone, of course—could once again be taken straight. It *was* a time in which George W. Bush was being presented by serious political commentators as Churchillian, after all. All *sorts* of ideas previously considered idiotic might plausibly be swallowed. It's not an unprecedented move (sigh; okay, we're *post*-ironic) and it ends up being an argument for the expressive potential of excess, of just letting it all hang out. So that a large number of movies that sure *look* cynically artificial in their self-conscious manipulation of the seemingly inadequate

narrative choices provided by their genres—from Baz Luhrmann's *Moulin Rouge!* to Rob Marshall's *Chicago*—turn out to be sincere. Hmm.

After all, the argument went, melodrama—in the larger sense of flattened and exaggerated categories of difference—without a shred of irony certainly seemed to be the order of the day as far as Fox News and the White House were concerned. (And a geopolitical conflict might be divided up between the forces of freedom and an axis of evil.) But that sounded like another way of saying our culture was regressing: that the choices weepies might present to us were of interest once again only because it was bread-and-circus time in the American Empire.

In 1987, though, and squarely within what most would have reckoned as the Age of Irony, Gabriel Axel's *Babette's Feast* took on the apparently narrow and outdated worldview of the weepie and provided an exhilarating sense of what it could teach us. A decade and a half before movies like *Far from Heaven* seemed to offer their take-it-or-leave-it option—either solemnly accept these conflicts on their own terms, or patronize the entire project—*Babette's Feast* opened up a more generous possibility.

In a lot of ways it seemed to be your basic weepie. It told the story of Puritan sisters, Martine and Filippa (their Puritanism mandated by their father to the extent that they were named after male Protestant theologians), living in a desolate and remote corner of Jutland in Denmark. Against all odds, each is given a spectacular opportunity for happiness and connection to the glamorous outside world. One catches the eye of a charismatic young officer in the army; the other has a special gift, if not genius, for singing. They're then joined by Babette, a French chef exiled by the violent upheavals in her country, who turns out to be, if we're to believe two different generals—and who'd have more authority, representing the outside world's opinion, than generals?—one of the world's greatest artists at what *she* does. And over the course of the movie, none of the women seem to do much of anything. For years.

We'd seen this before, in weepies: the tyrannically powerful family relationship that separates the heroine from her lover or aspirations. *Babette's Feast* gives us *both* frustrated desires, one in each sister. Martine's denied love; Filippa, her singing career.

So the movie, after five minutes of establishing the sisters' prim and spartan lives as elderly caretakers of their father's sect, startles us by dissolving to their

past and giving them back their youth and beauty. At which point the narrator compares them to flowering fruit trees, the fruit of which we see comically attracting suitors from both within and without the village.

As far as Dad's concerned, though, everybody can leave their baskets at home. Because he's there to deny the value of earthly pleasure or fulfillment as dangerous, and an empty illusion. He sends all suitors on their way.

In this kind of story, both romantic love and artistic self-expression—each of which might be considered emotional self-expression—are rejected as possibilities because in the face of familial and social pressure, the woman in question fails to act on her desire. The world is closed off around her while we watch, and she accepts to a large degree the unexamined assumption of her powerlessness. Mostly, she's acted upon. Her identity, then, seems to be formed around suffering. Hence the term: *weepies*.

We need to take a minute to consider how anomalous a genre weepies really are. Most movies—especially American movies—are essentially dramatic. As opposed to lyrical (concerned with mood or the inner self) or conceptual (with ideas). The weepie's the exception. It creates an interesting aesthetic problem for the people *making* it: How do you explore characters, in an

essentially visual medium, who are *not* constantly externalizing their conflicts in action? *Babette's Feast* takes that problem and turns it right around: makes it work *for* the movie. Douglas Sirk said this in an interview about his use of color in *Written on the Wind*:

Almost throughout the picture I used deep-focus lenses which have the effect of giving a harshness to the objects and a kind of enameled, hard surface to the colors. I wanted this to bring out the inner violence, the energy of the characters which is all inside them and can't break through.

He was talking about making style the primary vehicle for emotion, because so much that's crucial to his story happened *inside* his characters, and went unexpressed.

There's a moment about fifteen minutes into *Babette's Feast* that seems distilled from that kind of movie. We cut from Lieutenant Lorens (the future general who's fallen so hard for Martine and has now gone away) in the brilliant world at court (baroque salons, dancing swells) to the sisters in their nightclothes, alone in their bare bedroom. The waltz music bleeds across the transition, a forlorn sound bridge. One sister's at the window; the other, eyes open, has her face to her pillow.

We've glimpsed the glamorous, far-off world that's been forsaken. Then: two women in their dressing gowns, preparing for sleep. One gazes out the window into the night and asks, "Do you remember that silent young man who so suddenly appeared, and vanished just as suddenly?" The other turns, haunted, and says, "Yes." We're encouraged to imagine a vast stretch of time passed this way, in pursuit of another sort of time that never happened. We're encouraged to focus on the unspoken. To remember that in lives like these, especially, there's always more to tell than can be said.

In social terms, then, weepies concentrate on the point of view of the victim. Which may be why they've been so good at laying bare patterns of domination and exploitation in a given society. *Babette's Feast* works quietly to demonstrate that the dynamic of oppression operating between father and daughters has its social correlative; their little society's support for their arrangement is cued throughout the movie. Whenever we see suitors marching up to the pastor's home, we're provided with shots of villagers looking on with disapproval; when we subsequently see suitors turned away, frustrated, we're provided with reaction shots of the same villagers, once again assured that all is right with the world.

Even the suitors themselves seem to understand that they have no right to privilege their desires over the girls' father's. *I have a right arm and a left arm*, he explains to them in one scene. *Would you take either from me?* No one thinks to answer, Use your *own* arms.

The sisters, of course, are also complicitous in each other's situations. When the celebrated singer Achille Papin visits their dismal little village, and is transported by hearing the youthful Filippa's voice during church services, he begs permission to train her voice. His lessons become a courtship, his duet's lyrics comically appropriate to the occasion (—*"A voice within me calls you, it calls you from my heart; come now, don't fight against it, it is the voice of joy." —"I tremble, yet I listen; I'm fearful of my joy. Desire, love and doubting are battling in my heart."*), and we see Dad and Martine listening, holding hands in anxiety. They too know what's being enacted, and Martine isn't only comforting Dad. She seems to need comfort herself.

Soon after, when Filippa announces to her father and sister that she doesn't want her lessons to continue, her father and sister flank her and peer at her in the same way. The movie continually suggests that the sisters' sacrifices are mutually reinforcing: If Martine gave up what *she* gave up to stay, then can Filippa

really go? Wouldn't leaving be an even *larger* betrayal, of both her father *and* her sister?

After her decision, we're given a sequence of Filippa knitting and distraught, and Dad, then Martine, noticing and saying nothing. We read into those reaction shots sympathy, restraint, decorum, and complicity.

In most movies, drama moves toward its resolution by making its conflicts more and more externalized. Someone decides he's finally going to face down Black Bart; somebody else decides to go after that big fish. In the weepie, because of the way social pressure limits the range of both action and self-expression, intense feelings are bottled up, and aggression is worked out by proxy.

A surprising amount of aggression builds up in *Babette's Feast*, surprising because these are basically good people, and because a lack of harmony has supposedly been legislated out of this sect. The dozen members meet periodically to renew their commitment to peace and brotherhood. They've voluntarily given up nearly everything, so they should have almost nothing to fight over. They live in identical houses and eat the same brown slop. And yet they still bicker. They snipe. They hold lifelong grudges. About

what? I cheated you out of some of your brown slop. You never should have kissed me thirty years ago. What the narrator with some pained dismay terms the "schisms" that erupt within the sect is, we realize, aggression being worked out by proxy. But who's the aggression really directed against, and why? The sisters, for their kindness and extra patina of virtue (after all, who *else* in town proved themselves by turning away the attentions of a dashing lieutenant and a celebrated singer?). The sect's founding father, for having gotten them all into this mire of self-effacement in the first place. And primarily, of course, themselves, for having signed up for this, and carried it through.

This is the little social tundra where Parisian gourmand Babette (played by Stéphane Audran) seeks asylum, bearing a letter from Papin. From it we learn that her husband and son have been murdered, her calling taken away, her whole life annihilated. The deal she makes that night—the only deal the stubbornly self-denying sisters will offer her—is the deal she'll live by for the rest of her life: she'll work for them for no wages. Because, as she tells them, if she can't, she'll die.

It's a crappy deal. But throughout the movie, she's uncomplaining. And as she goes about her business,

poker-faced, the movie quietly reminds us of her un-happiness.

Right after her arrival, we watch her weathering with infinite patience the sisters' rudimentary run-through of the glories of Danish cooking. They show her a spoon. They show her how to stir. They show her brown glop. The sequence is even more powerful in retrospect, when we, like the sisters, realize what a humiliation this must have represented for one of Paris's greatest chefs, and how uncomplainingly she accepted it.

Periodically thereafter we'll see Babette alone, her face composed, gazing off into space. Such moments will change in retrospect, once we learn just how much has been stripped from her, how much her world has been shattered. But before that, when we look at her, it's almost as if, like the sisters, we want to believe that she's thinking, *What a nice place. I'm so glad to be here.* Audran infuses her performance as Babette with such restraint and dignity that it allows us to make the same mistake the sisters do: to believe that Babette's really *not* that unhappy.

The revisitation of the past is central to both the weepie's structure and emotional power, since lost, forsaken, and reclaimed opportunity is always at the heart of

the matter. And it's not hard to figure out why, since it *was* a genre designed to be consumed by women. (The screenplay's based on Isak Dinesen's short story, and she knew a little bit herself about such matters.)

The sisters revisit themselves in the flashback to their youth, and Babette, too, is given back her past. First because of a stroke of luck: a letter arrives from France informing her she's won the lottery—ten thousand francs, a staggering sum. (And it's a measure of the climate of powerlessness in weepies that more than any other genre would dare, its plots turn on outrageous occasions of good and bad luck.) And second, and more importantly, she's given back her past because of her generosity.

The sisters had been planning a dinner for the surviving sect members to celebrate their father's memory. Babette pleads to be allowed to make that dinner, with her own ingredients and at her own expense, and the sisters, reminded that she's never asked them for anything but this, relent. But immediately they begin fretting that their sect's going to be sinfully compromised and opened up to hidden, dangerous powers.

Which, it turns out, it is: to the sensual, to be specific. The sect's solution to this problem is yet another form of aggression enacted in a bottled-up way: they resolve

to deny their senses. Whatever it means to Babette—who has, remember, only asked for this one thing—and however much it might disappoint her, the sisters and sect-members resolve not to convey any appreciation, or even reaction.

They resolve to stay their decades-old course of denying a certain kind of human connection based on pleasure. They resolve not only to say nothing about the food, but to not *experience* it, either; to not *taste* it. This, we register, is an *unusual* level of self-denial. As one sect member puts it, memorably, justifying their decision, the tongue is "the source of unleashed evil and deadly poison." Well. Okay, then.

They then sing the hymn "Jerusalem, My Heart's True Home," underlining the limitations of a life based not only on faith—for their faith *is* real, and the movie *does* respect it—but also a denial of the world. Their true home is *Denmark*. But they refuse to live in *this* world. They live as though the body is the spirit's implacable enemy. But *Babette's Feast* turns out to demonstrate that the body is the spirit's ally; in fact, the spirit's true home.

Imagine, for a moment, that Babette is what the movie claims she is: an artist. What she constructs by the end—her crowning triumph—is collaborative. Even

this crew—and of course, the special nature of her triumph is that she's brought heightened pleasure and appreciation to even *this* clutch of lumps, who A) have no way of contextualizing their experience (Is this a great red wine? Is this a great turtle soup? How would *we* know?) and B) have no intention of allowing themselves to do so, anyway. Am I crazy, or is this what *all* art aspires to? Isn't this the opposite of preaching to the converted? What's great about the collaboration between artist and audience in this case, once the sect starts being ravished by the food, is that it's *their* triumph, and not just Babette's. These people, who've had salted cod and ale bread their whole lives, have begun to recognize nuance and difference and a range of response utterly unknown to them previously. They've become—she's made them—better readers, and happier readers, and their text is the world itself.

The sisters want to have a dinner for their father—an offering to his memory and a celebration of their faith in it—but they're proud of the fact that it won't involve any fuss. They're going to celebrate the anniversary of their father's birth with "a modest supper and a cup of coffee." Babette proposes the opposite: a gourmet French dinner. She gives them, implicitly, her opinion: You want to offer up glory to God? Then try

something glorious. You want to celebrate God's love, and your father's? Then try something celebratory. She tells them, when pleading to be allowed to do it, "Hear my prayer today. It comes from my heart." *My* prayer. We've *heard* yours, and I respect it. Now hear *mine.*

It's not a coincidence that Babette's imported ingredients take the form of exotic life: a little cage of quails, a mournful and surreal sea turtle, hissing and dripping with sea water. The village comes out to see the ingredients trundled into town, not only because this is a place so divested of event that a letter from France is a big deal but because these ingredients represent a little parade of plenty down the street.

The ingredients form both a spiritual and secular metaphor, as in: you can make your meals with two ingredients, or with hundreds. It's not an issue of which would be better, finally; it's an issue of possibility.

Babette in her preparations provides even the linens and the crockery; she works, in other words, to transform the sisters' home into the Café Anglais, that transcendant place where she worked her artistry, and the lingering nature of a gorgeous slow pan over the transformed table with its silver candlesticks emphasizes both the extent of the transformation and the sect members' stunned surprise.

It's a moment Sirk would recognize. The look of the movie at this point has become the primary means by which it's communicating. It's hard to think, in fact, of another movie in which the contrast of emotional and spiritual states is played out so comprehensively in visual terms. Early on, the village's starkness and austerity and lack of possibility, not only in economic but also in emotional terms, are all established visually through its otherworldly simplicity: grey thatched roofs, whitewashed walls, bare ground. The only beautification possible seems to be the water that Babette slops on the windows to wash them.

And then that austerity and lack of possibility get transformed. Once dinner preparations are underway, the movie's palette changes from the cold greys and whites of the sisters' home and village to the warmth of Babette's kitchen and the assembled ingredients. From bare surfaces lit with blue and white light to cluttered textures and shapes in red and brown and gold. From only what's necessary to more than one would desire.

Come inside where it's warm, the sisters tell their guests when they arrive, but the anteroom they usher everyone into looks only marginally warmer than the outside. *Come inside where it's warm*, Babette tells the general's coachman, and she ushers *him* into a room

lit with the warm light of a roaring fire. *Come inside where it's warm* is what she's saying to *everyone* at the dinner, and her transformation of the dining room is what allows that warmth and plentitude to be spread around. The guests, sitting down to eat, say a prayer to reaffirm their unwillingness to acknowledge the power of the here and now: "May the bread nourish my body; may my body do my soul's bidding." "Like the wedding feast at Cana," one of them adds, "the food will have no importance." But they're forgetting that the story of the wedding feast at Cana is only *known* to us because the food *has* importance: Mary asks Jesus to do something about the fact that their hosts have run out of wine; Jesus obliges. He doesn't say, "Who needs wine? Water's fine for me."

But whatever our pinched little sect members have resolved to ignore, they're not going to be able to pull it off. The comic impossibility of not reacting to *this* food is conveyed by the movie's ability to *put* the food, in all of its exotic lusciousness, right up in our faces.

Lorens the general, meanwhile, has apparently not found happiness or meaning in his quest for career. His shock at the transformed table is one of the comic highlights of the movie. And his stunned appreciation—and comprehensive knowledge—of what

he's eating is crucial, since the filmmaker can *show* us how beautiful the food is, and set up a contrast with what's come before, but he can't visually render *taste*. We don't have any way of knowing how astoundingly good this is. And at first the sect members are committed to *not reacting*. So we need the general's pleasure to cue what we imagine would be our own.

Lorens, like Babette, and like the sisters, is having a glorious aspect of his past returned to him—and *not* as an illusion. Or as a memory. And as they need to in the larger sense, the other diners learn by his example: the way he drinks turtle soup becomes the way they drink turtle soup. The way he gets at the leftover sauce around his quail becomes the way they get at their leftover sauce. The way he finally comes to understand this as an act of love, of giving, and not a sinful indulgence, is the way they finally come to understand it, as well.

He tells the story of the Café Anglais. A French general—the same one who killed Babette's husband and son—told Lorens that she had the ability to transform a dinner into a kind of love affair that made no distinction between physical and spiritual appetite. Martine and Filippa, after a lifetime of self-denial, savor their food. Lorens makes a silent toast to Martine. And one

of the guests points out by way of dinner table conversation that "the only things we can take away from this earthly life are what we have given away" and goes on to add that "if that's the case, our sisters will be rich indeed." But who has been the founder of this feast? Whose generosity is this? It's a generosity that's gone way beyond spending money. It's involved spending money on this sect, which will have no idea of what it's eating.

By the time the fruit arrives we're in a sequence of pure enjoyment, with the camera lingering on close-ups of faces chewing, savoring, and beaming in various directions. We gape at an enormous pile of fruit, an image of serenity and plenty that extends back beyond the still lifes of 17th-century Dutch painting to the frescoes of republican and imperial Rome. And Lorens, who's been unable to make any headway in getting this crowd to mention how good the meal's been, stands for a toast and confirms for everybody what's just been enacted. "Mercy and truth have met together," he announces. Babette has demonstrated that the two are *not* mutually exclusive. Righteousness and bliss, he tells us, have kissed one another. Mercy, he goes on to suggest, in an absolutely beautiful formulation, imposes no conditions.

Every so often—fleetingly perhaps, but genuinely, nonetheless—everything we've chosen *and* everything we've rejected—all of it—is granted us. Every so often the world's grace allows us a greater glimpse of what's possible, of what we're capable of.

So something very cool is happening here to the weepie. If *Far from Heaven* seems to suggest that we can either take the traditional weepie's array of shrunken options seriously on their own terms or see them as the basis for camp, *Babette's Feast* sixteen years earlier had already opted for Door Number Three. Women in weepies had two options: self-denial or indulged desire. The former led to spiritual fulfillment; the latter to corruption. That's the movie that Martine, Filippa, and their father think they are. But it turns out the formulation was too narrow. It turns out that what's liberating—in a secular *and* spiritual way—is the embracing of life and human connection. Self-expression itself.

After dinner, the villagers head outside, their hands linked, forming a circle under the stars, their faith renewed and strengthened. The ironies of their insulation are still present. They're tipsy, of course; that's one reason everyone's so happy.

And when they sing, continuing their hymn, "*so that our true home we shall find,*" we cut to Babette, all by herself, and exhausted. Their happiness at this point is her doing, and their happiness doesn't eliminate the irony and sadness of her position. Where's *her* true home?

To confirm that irony and sadness, she then tells the sisters her terrible secret: she was that chef at Café Anglais; she overheard Lorens talking during the meal, and she had to relive all of that pain and loss while preparing their food. While she was making this meal for all those people who weren't going to appreciate it, she was forced to remember having done the same thing for the man who killed her family. The sisters didn't know that while it was going on, and neither did we. We couldn't even see it on Babette's face. The sisters still don't get it.

But it doesn't matter. And none of this was only for them, anyway. Babette's been doing this all along to express herself, in world that wouldn't allow that self-expression.

Weepies were about the expression of a repressed female voice. And *Babette's Feast* is the slyest and most benign sort of reclamation project, as far as that genre's concerned. If women in weepies always carried the burden of feeling for everyone, and were never allowed

to express what they felt, Babette—and because of her, the sisters—finally get to express themselves fully, and nearly *exclusively*, through the medium of film itself, through the film's look. One of the central characteristics of the weepie—that preoccupation with time lost, or never experienced—is being recouped here, because that return to memory in *this* case is not inherently saddening or paralyzing. In one of the least likely places on earth, Lorens has found the Café Anglais recreated here, in the present. Martine has had what she shared with him returned to her. Filippa has had what *she* shared with Achille Papin returned to *her*.

Memory here no longer tyrannizes. These women, like all those other women, have gone nowhere geographically. But they've had an amazing adventure nonetheless. Filippa, having been given such a gift, reciprocates, in the movie's last moments, with the words Papin used to console *her*: "This is not the end, Babette; I'm certain it's not. In paradise you will be the great artist that God meant you to be." It's Papin's expression of love, which is heartfelt, and it reoccurs, both absurd and moving, like a beautiful chain letter, returning after all these years. "Oh, how you will delight the angels," she concludes. It's the only thank you she can articulate.

FOOL ME TWICE, SHAME ON ME:
Saving Private Ryan and the Politics of Deception

In the stampede that occurred in 2004 to explain how it was that some 58 million voters had decided to return the George W. Bush administration to power, it was repeatedly noted how often polled voters mentioned *safety* as a crucial issue in their decision: in perilous times, they confided, they'd go with the candidate who seemed more likely to allow them to feel *safe*. And a startling number of Americans, even intelligent ones, seem to have decided that, whatever else separated the two candidates, George W. Bush was in some important way *stronger*. This was an interesting perception, given that the other guy was a certified war hero, and it was no secret that Bush had avoided serving in the very same war; given that Bush had pretty clearly let Osama bin Laden, the embodiment of our

159

terrors, escape when American forces had him cornered in Afghanistan; and finally, given that part of the Republicans' campaign strategy had been to argue that we were *now* in more danger than ever. (It was an impressive sleight of hand, that last strategy: *Things are now scarier than they've ever been. Thank God we were in power when* that *happened*.)

One of the ways the Republicans, with the collusion of the national media, managed this stunt was by supporting a candidate who made clear that he was *so* firmly set in his ways that even more or less indisputable evidence of his having made a catastrophic mistake caused him no second thoughts. In other words, right or wrong or horribly wrong, he was no waffler—a quality a large number of us, apparently, found reassuring. (As in: even if it sure *feels* to those of us in the backseat like we're doing some unplanned off-roading, Daddy *says* his hand is firmly on the wheel. So we can go to back to sleep.)

But what other reasons caused so many of us to fly so blithely in the face of empirical evidence? Where *did* we get this capacity to imagine that horribly complicated messes have been ironed out just because someone has looked us in the eye and told us so? I don't know about you, but *I* keep getting it from the movies.

Steven Spielberg's *Saving Private Ryan* was one of those war movies found pleasing by conservatives *and* liberals, and it's not hard to figure out why: there was more than enough *war is hell* stuff to satisfy the left, and there was an even greater helping of *well, it may be hell, but it sure brings out the best in us, doesn't it?* raw meat for the right.

The movie duplicated almost exactly for Spielberg the critical and financial success he'd had with *Schindler's List*, which shouldn't surprise anyone, since it also mostly duplicates the earlier movie's design. Both use a set piece sequence, in each case around twenty-four minutes long, to immerse us in a hideous historical experience: in *Schindler's List*, the liquidation of the Kraków ghetto; in *Saving Private Ryan*, the slaughter of the first waves at Omaha Beach during the Normandy invasion. In each case, apparently, no effort has been spared in terms of verisimilitude. The idea is to then let the bracing resonance of those sequences seep forward throughout the rest of the movies, thereby encouraging us to overlook the fact that from there on in, we're given pretty much exactly what we want.

Spielberg's landing on Omaha Beach features the best efforts of not one but three full special effects teams, and it's frequently stunning: we're given a

visceral sense of the helplessness of someone thrown into the mechanized slaughter of this kind of modern warfare. Hundreds of men, obstacles, and explosions crowd into each image, allowing us to glimpse what claustrophobic killing zones those relatively small stretches of beach really were.

This is the horror-of-war stuff for the lefties, and it's genuinely horrible. This is the stuff that gives the movie its authority. This is the stuff that allows us to swallow the bitter-coated sugar pills to come. A huge part of what's so wonderfully relentless about the sequence is its obsessive interest in the physical manifestations of what's being poured down upon these men: there are bullet and shell impacts everywhere, and we're constantly startled at how fragile human bodies turn out to be in the face of high-caliber weaponry. Every square foot of a shot is filled with exploding squibs, and added to that are computer-generated detonations as well. How *many* squibs are used in the sequence? According to industry reports, seventeen thousand.

Even for filmmaking, then, that required a spectacularly complicated choreography: a lot of the explosions were generated by networks of thousands of feet of compressed air tubes, beneath the sand for greater safety, but even so, you couldn't be standing on them when

they went off. That meant all of the principal actors, all of the extras—700 extras, from the Irish Army—and all of the cameramen had to rehearse over and over again exactly where they were running and when. Where no actors would be running, *real* high explosives were planted. For the real high explosives, special sand, pre-sieved for safety, had to be trucked in. Since, if you set off real high explosives in sand, whatever rocks and shells are present will become real shrapnel.

Some of the most noticeable and convincing horrors involved guys' limbs being sheared off as they were blown up into the air. Those shots involved—are you ready for this?—amputee stuntmen with prosthetic limbs. And for the actors, the sheer complexity and noise of everything involved, added to their fear of missing their marks and screwing everything up or getting their feet blown off, made for something as close to actual combat conditions as they'd ever get.

All of this obsessive work pays off. The heart of the sequence's power comes from its ability to render both the randomness of the ferocity and the ferocity of the randomness. But what makes it endurable—or even pleasurable—are the patterns *imposed upon* that randomness. The audience sits there buffeted and terrorized, thinking: *What a shit storm. We sure could use*

someone to get us out *of this*. And luckily, it turns out that Tom Hanks is on the beach with us.

He's our Captain Miller, and we've pretty much clung to him throughout the whole frightening ordeal. He was on the LST when, to our great shock, everyone in the front ranks started getting massacred without even being able to disembark; he was the one who took charge and saved who he could by ordering everyone left over the sides. He brought some wounded ashore; he did what he could to impose order and rally the grunts in the water and under fire to a common purpose. And though the sequence is all about the chaotic lethality of this environment, the most horrible and memorable wounds are carefully spaced out to allow us time to process them and get our breaths. Three different times a soldier the captain is trying to help is killed, and he models our response for us, looking on in stunned and helpless horror, before forging on grimly. Meanwhile, of course, *he* keeps surviving, to our immense relief, and he allows us the pleasure of watching him escape unscathed to orchestrate the breakout of the beachhead.

What *do* you do as a filmmaker when you're faced with having to render something as awful and

non-narratable as war? It's like trying to map the winds in a hurricane. Spielberg, logically enough, opts for the same framework that worked so well for him in *Schindler's List*: the binary of catastrophe and heroism, in which catastrophe creates the occasion for heroism, and heroism gives meaning to catastrophe. Boy does *that* generate some big advantages, in terms of pleasing an audience. Catastrophe doesn't feel so *draining* anymore. Because *all of that suffering has had a point*, has led to a greater good. It's not an accident that Spielberg has made three films about WWII and none about Vietnam.

Tom Hanks has built a career on his persona as an amiably likeable guy with rock-solid down-home values; we're pleased and reassured to note that that's what he's selling in *Saving Private Ryan* as well. He turns out to be our dream officer: half Sgt. Rock and half Mr. Chips, a father figure who can both settle a nervous stomach and take out a Tiger tank. He's astoundingly resourceful and a superb teacher when it comes to tactics and weapons. (Preparing for the movie's climactic battle, he alone knows the best way to deploy the few troops he's got to defend a bridge against an oncoming armored SS division; he alone knows about such homey and lethal improvisations

as sticky bombs, which involve demolition material packed into socks and covered in axle grease.) He's astoundingly good at the psychology of his men. When one of them is killed because our captain insisted on policing up a machine gun nest that could have been avoided, he defuses a potential mutiny among his ranks by Opening Up. He's been secretive about his background, see, so secretive that the men have made a game of trying to guess where he's from and what he does. And his background turns out to be the epitome of wholesomeness: he's a schoolteacher from Pennsylvania, and a Little League baseball coach. Perhaps he bakes apple pies on the side. He reads Emerson and Tennyson and still excels at the common touch with his men. He's so morally self-aware that he says things like "Every man I kill, the farther away from home I feel." The movie simultaneously tells us *he is just a regular guy* and *he is the greatest guy ever*. We swallow the paradox whole, because it's so deeply flattering to us. Tom Hanks is no different than you or I. And Tom Hanks is truly great.

And with great men, acts of faith work out. Great men *know*. The Private Ryan of the title needs to be saved because his three brothers are all killed within a few days of each other and when General George C.

Marshall gets wind of it, he decides that their mother has suffered enough. Problem is, Ryan was part of the airborne drops the night before the invasion: drops that suffered appalling losses and scattered men all over northern France. General Marshall resolves to send a company to find and save him. When his subordinates protest that for all they know, Ryan isn't even alive, Marshall answers, "He's alive." The same way our Captain Miller, later looking through a bag of hundreds of dog tags of the already-dead from the airborne division, suddenly decides, "He's not in here."

And Captain Miller's not the only thing in the movie that's reassuring. During that spectacular set piece of an opening, *Saving Private Ryan* feels like it was made by someone who'd actually been in the Normandy invasion. After that, it mostly feels like it was made by someone who's seen a lot of war movies. Sometimes it feels like a compendium of Spielberg's favorite moments from other war movies. Captain Miller and an unnamed GI have an exchange under fire at the base of the bluffs off the beach—"Who's in command here?" "You are, sir"—that echoes the famous moment in Coppola's *Apocalypse Now*, with Kurtz at the Do Long Bridge: "Who's in command here?" "Ain't you?" There's a scene of the agony experienced by an

entire squad unable to help a buddy who's still in range of an unseen sniper that's straight out of Kubrick's *Full Metal Jacket*. Underwater bullets torpedo about, colliding with unsuspecting swimmers, just as they did in Peter Weir's *Gallipoli*. And majestic and melancholy music—somewhere between the elegiac and martial—is heard whenever Captain Miller is thinking sad thoughts or pondering the costs of war, music that sounds poached from Jerry Goldsmith's score in Franklin Schaffner's *Patton*.

So if the design of the opening shit storm was to establish authority by disorienting us, the design of the rest, for the most part, is to *re*orient, and, gradually, reassure us. To that end, the composition of Captain Miller's squad is itself astonishingly standard issue: one Italian, one Slovak, one Jew, one rural Southerner. There's even a guy from Brooklyn. The rural Southerner, of course, in the tradition of Sergeant York, the legendary marksman and hero of World War I, is a backwoods wizard with a rifle and is full of homespun good sense. He's also, we notice, lifted from Kurosawa's *Seven Samurai*: he's our Kambei: our dream of the perfect warrior, with superhuman skill, superhumanly *surgical* skill. (He kills the unseen sniper by putting a bullet *through the sniper's scope*

and eye at 450 yards in a driving rain.) Like Kambei, this master killer is so at peace with himself that he can sleep anywhere. (The rest of the squad notes his otherworldly ability to drop off at a moment's notice.) And like Kambei, since he seems to be pure warrior, he can't, of course, outlive the war.

As has always been the case in his career, an intimate knowledge of his genre is what enables Spielberg to be savvy enough to vary the formula when necessary. When you subtract the two set piece battles that bookend the movie, by far the most memorable scene is the one in which the Jewish squad member is killed during interminable and agonizing hand-to-hand combat with a Nazi. The killing takes place while the squad's New Guy and audience surrogate, Upham, played by Jeremy Davies—you know: the guy who's the convenient reason for all the exposition, and who needs to learn about war, etc.—tries to work up enough courage to drag himself up the stairs of the shattered house where they're struggling so he can intervene. The scene is unsettlingly powerful precisely because we've seen a version of it so many times before, and we know how it comes out: either Upham gets up the nerve to get up those stairs and save his friend, or his friend kills the

German. But neither happens. And on top of that, the Jew—so proud of how personal his fight with the Nazis has been—is killed in a way that seems grotesquely ironic: stabbed gradually, while being whispered to, as if by a parent or a lover.

It's a great scene. And we see Upham's anguish about his failure immediately afterward. (We should have seen it coming, actually, since Jeremy Davies was principally recognizable at that point as the lamentably weak-willed protagonist of David O. Russell's *Spanking the Monkey*.) But then we never see any *more* of his anguish about it. Once the scene's over, the movie wants us thinking in different directions. So Upham—who plays a big role in the movie's final scenes—is alternately terrified, resolved, and grimly sad. But the issue of his torment, or shame—an issue we'd have thought, from what we've learned about him so far, would have haunted him forever—is dropped.

One of the oldest traditions in war movies is the scene in which the soldiers debate the ethics of what they're doing. This is always done during a lull in the action, and, in American movies, it's done very democratically to demonstrate what American men are fighting for. And to demonstrate that American men can enact

what they're fighting for while they're fighting for it. Americans gripe, colorfully, and cynically, and then do their duty. So we're privy to a few debates on the issue of the ethics of risking eight guys to save one Private Ryan. And during those, Captain Miller displays the exact degree of cynicism we expect from a battle-hardened and righteous officer who's seen combat and is fed up to here with pissant bureaucrats.

"You want to explain the math of this to me?" one of his men asks, very reasonably. The captain, always on the lookout to allow his men to instruct themselves, responds amiably, "Anybody want to answer that?" And the various members of the squad characterize themselves in their attempt to do so. Then he clarifies: they all have duties as soldiers that supersede their concerns for their own safety, especially if the mission's FUBAR: fucked up beyond all repair. What would he say to a superior officer about the mission, he's asked. In that case, he responds, he'd answer that "this is an excellent mission, sir, with an extremely valuable objective, sir, worthy of my best efforts, sir"; moreover, that he feels heartfelt sorrow for the mother of Private Ryan, and that he's willing to lay down his life and the lives of his men—especially his questioner's—to ease her suffering.

Because of course, he's already recognized as a hero, and this is what heroes do. "It was a tough assignment," his superior officer told him when giving him the mission. "That's why you got it."

Before the mission's handed out, we travel to Mrs. Ryan's Iowa farmhouse—a farmhouse filmed with such loving attention to fawn-colored fields of waving corn and plain, unvarnished wood that it seems a hallucinogenic distillate of Norman Rockwell and Andrew Wyeth—to find her washing dishes uncomplainingly behind hand-laced curtains. We watch as she receives the unimaginable news of her three boys' deaths. She sinks to the rough-hewn planking of her front porch. So: Should somebody go after the final Private Ryan, or not? What do we think: Are we in *favor* of a mother's agony?

This is the right thing to do. This is the thing that redeems everything else. The movie throughout its length provides *insistent* ratification of that notion. Despite their skepticism and bitterness, in the lull before the final battle, the surviving squad members get a chance to talk about home, and moms, and, therefore, indirectly, why they appreciate the deeper significance of this mission. Another captain, Ted Danson, having dropped in from

Cheers, takes a moment to tell Captain Miller, "I understand what you're doing. I have brothers, too. Find him. Get him back." The medic of the squad dies calling for *his* mama. As do three different GIs on the beach in the opening scene. And when Private Ryan is found and protests, "Why not any of these guys? They've all fought just as hard as me," our Captain Miller tells him, "Is that what they're supposed to tell your mother? When they send her another folded American flag?"

The problem of what to do about this last Private Ryan, we're shown, went all the way to the top. In the case of the US Army in World War II, that's Chief of Staff George C. Marshall, the closest thing you can find in the entire history of the war to a man about whom historians will say nothing negative. And *he* then uses as decisive evidence of how he came to *his* decision an appeal to an even *higher* authority: perhaps the highest authority America has ever produced, in terms of a generally agreed-upon consensus combination of intellect and moral courage: Abraham Lincoln. Are you wondering about the ethics of risking eight guys (and, in the end, getting at least six killed) in order to rescue one for the purposes of public relations? Well, *Abraham Lincoln* isn't.

While we watch, General Marshall reads, movingly, from a letter he's marked from Lincoln to a bereaved mother of five sons lost in the Union cause. Then he announces that Ryan's alive, and that they're going to get him the hell out of there.

It's worth noting that Harve Presnell, the actor cast as Marshall—who for Spielberg is all cavernous rumbling and stentorian authority—is the same guy the Coen brothers cast as William H. Macy's comically tyrannical and buffoonishly inflexible father-in-law in their blackly comic *Fargo*. Presnell in both movies is doing essentially the same shtick. Different strokes for different folks.

The definition of the thinking man's epic, as opposed to the epic, might be that the former raises the difficult questions inherent in the latter, and then pretends to have answered them. As one of my students once put it, the regular epic doesn't seem to want you to think. But the thinking man's epic wants you to *think* that you're thinking.

Just how relentless are the reassurances that the mission is worth it? Well, another venerable, if not hallowed, tradition of the war movie is that the noncommissioned officer—the sarge, the tough old bird who *earned* his stripes, rather than getting them through

some kind of class advantage—is the ultimate authority on what's right. (John Wayne, up until he hit his sixties, played almost exclusively non-commissioned officers.) Our sarge is Horvath, played by Tom Sizemore as the dream sergeant: unquestionably loyal, completely competent, and tough as an old boot. (Early on in the final battle he's shot in the side and reacts the way you or I might to barking our shin.) So, what's our sarge's ultimate take on the mission?

Captain Miller, worn down by two hours' worth of difficulties, and discouraged, asks his sergeant what *he* thinks. Sergeant Horvath says that part of him thinks they should just leave Ryan and get the heck out of there. (Ryan's announced that he's not leaving; he's staying with his compadres in a near-certain suicide mission to defend a bridge from the oncoming Germans.) But Horvath goes on: "But another part of me thinks: What if by some miracle we stay, and actually make it out of here? Someday we might look back on this and decide that saving Private Ryan was the one decent thing we were able to pull out of this whole god-awful shitty mess."

And just like that, the movie performs its surprising sleight-of-hand reversal: saving Private Ryan *would* be a better thing than saving some other guys. Even multiple

other guys. The movie goes on to explicitly explain what will make these men's sacrifice worthwhile: Private Ryan needs to turn out to be an amazing guy, who lived an amazing life. It'll be all right, in other words, that all these other guys died, as long as the movie's able to establish that he *was* in fact worth six of them.

Consider how much more uneasy we would have been in this movie if Private Ryan had turned out to be unlikeable. Or heck, let's not even go that far: imagine how uneasy we would have been if Private Ryan had turned out to be Steve Buscemi. If Tom Hanks is our dream of the American officer, then Matt Damon's Private Ryan is probably our dream of the American foot soldier: dazzlingly handsome, hearteningly unpretentious, and unhesitatingly ready to lay down his life for his buddies. He's too good a soldier to want to be saved. Along with Captain Miller, he's the very best America has to offer. So Captain Miller stays, and fights with him, and dies. The older paragon lays down his life so the younger one can carry on. One of them *has* to lay down his life, since part of the point here is that heroism means that sometimes you have to die for your country.

Still, he makes clear he doesn't want to die for nothing. He wants some assurance that Ryan's life will

amount to something, after all. He has a dying wish for him: *Make it worth it.* "*Earn this*," he whispers, agonized, before he dies. And the movie decides to provide us with even *that* assurance, by flashing forward to the future: yes, Ryan *did* earn it. How do we know? Well, first, he brings with him to the memorial site in Normandy his handsome family, including his distractingly beautiful Aryan grandchildren, including three blonde women whose bodies remain so persistently on display that we find ourselves wondering if Private Ryan's main contribution has been to the Playboy Mansion. And second, breaking down with emotion, he asks his wife, and his wife tells him. He *has* been a good man. It *was* all worth it. "Tell me I've led a good life," he says to her. "Tell me I'm a good man." "You are," she tells him. He gathers resolve from her answer and salutes Captain Miller's grave. And the camera tracks in to the gravestone and Captain Miller's name, and dissolves to the American flag, before fading to black.

So, no surprise: *Saving Private Ryan* delivers on its title. It's about a rescue mission that has a million-to-one odds against it that succeeds. Ryan, we're told repeatedly, is not only a needle in a haystack, but a needle in a haystack that's presently undergoing a shit storm. Nevertheless, our eight-man patrol locates, and saves,

their man. Despite an all-out assault from an armored panzer division. In the process, they suffer some saddening losses, kill a huge number of Germans, and save the day by holding a key strategic point until reinforcements can arrive. We wouldn't have it any other way. We wouldn't tolerate his not being found; we wouldn't tolerate his being found too late. And we wouldn't tolerate the movie's having left us with the notion with which it teases us: that saving Private Ryan is, finally, a public relations gesture that's wasteful of human life.

Saving people has of course been the main narrative feature of most of Steven Spielberg's work. And here again we notice that *Saving Private Ryan* employs the same narrative and thematic model as *Schindler's List*: not only that of the successful rescue, but the successful rescue that explicitly transcends and redeems the previous extremities of suffering, so that it not only provides meaning, but works to banish the darkness. And it does so by suggesting, oddly, that all people are *not* created equal. The most attractive Jews are saved from the Holocaust in *Schindler's List*; the most attractive black people are saved from slavery in *Amistad*; the most attractive Irish boy in the entire European theater is saved from World War II in *Private Ryan*. In all three movies, nobility and goodness eventually

seem to insure that the most beautiful and deserving find justice.

Again, though, Spielberg is always savvy enough to vary the formula with the deft inversion or variation. If we've done one saving many, in *Schindler*, how about, in *Private Ryan*, we try many saving one?

The movies, in fact, are often constructed as a string of successful rescues that we desire—the Indiana Jones series being the most transparent example—which means that, in terms of the expected escalation in the intensity of our pleasure, the final rescues in particular have to come just when it appears that no rescue is remotely possible. That's the move Spielberg has been repeating successfully for fifty years. Audiences haven't started complaining yet. So there's Captain Miller, stuck splay-legged on the bridge, shot through the chest and dying, with only a puny .45 with which to face an oncoming Gargantua of a Tiger tank. He shoots and shoots and shoots and just as we despair, the thing magically explodes. Turns out a P-51 has arrived in the nick of time. If the moment seems, for all of the pleasure it provides, vaguely familiar, well, that's because it's identical to the end of *Jaws*, in which Roy Scheider, the last guy left, clinging to the

mast of his sinking boat, shoots his pitiful rifle at the onrushing twenty-seven-foot great white until it, too, magically explodes.

So it doesn't seem controversial to suggest that *Saving Private Ryan* is a state-of-the-art entertainment that mostly uses a large historical subject as its medium. Such entertainments are designed to make audiences feel good, because audiences *want* to feel good. Such entertainments may tell the audiences what to think, but they make sure that what they're selling is very close to what audiences already *do* think. Or *wish* to think. As any number of moguls have pointed out before, you don't make $200 million by arguing with your audience.

In the documentary that accompanies the DVD edition of the movie, we see glimpses of the first two movies Steven Spielberg ever made, both boy's versions of World War II: *Escape to Nowhere* and *Fighter Squadron*. Both were made when he was fourteen. Both feature, unsurprisingly, lots of glory and a precocity for special effects. (In one, he renders explosions with small planks and carefully marshaled piles of dust.) The documentary goes on to announce itself and *Saving Private Ryan* as hagiography: the latter was made, Spielberg tells us, to honor those heroes who served in the war. His dad, who served in Burma, relates that

movies like his son's serve a purpose: "The more you talk about the horrors of war, the more you're less likely to try to get involved in another one." But that's followed immediately by Tom Hanks announcing that these guys who served at Normandy—who were only given their chance to show what they could *do* by the crucible of war—deserve our applause, deserve medals, deserve parades, and deserve our thanks, and our highest respect. War is hell, sure, but war makes heroes, and that's what should occupy our attention. The documentary ends a few moments later with a close-up of Hanks's eyes as he attempts his thousand-yard stare, and we hear the voice-over of Tom Sizemore's Sergeant Horvath, ratifying the search for Private Ryan: "Someday we might look back on this and decide that saving Private Ryan was the one decent thing we were able to pull out of this whole god-awful shitty mess." Except this time, the "shitty" is left out.

*

A recent article in the *New York Times* noted the fact that the families of servicemen lost in the war were united in grief but divided by their opinions of the war. The *Times*, in its inimitably Even-Handed way, quoted doves

and then hawks on the subject. Then it quoted a grieving father named Nelson Carman from Jefferson, Iowa, "a farming town of 4,500," in order, apparently, to provide the newspaper's cherished More Reasonable Middle Ground. Mr. Carman related how he told one of the left-leaning grieving mothers, "Let's not go there with the politics. . . . To bring politics into our sons' sacrifice is just something that is not conceivable to me. If you have another set of issues, especially political, that you're dealing with, that's just another hurdle you have to get over."

It's a jaw-dropping argument, in logical terms, but one that Americans make all the time, and refuse to question: *you shouldn't bring politics into the discussion of whether or not deaths in war are justified.* But war is not the equivalent of a natural disaster. War is begun and then conducted *because of* the decisions of individual men. Men who subsequently have a vested interest in disseminating the idea that it's obscene to try and introduce the idea of politics when discussing their war.

Let's not talk politics; let's just honor these brave men who have suffered, our leaders tell us. Why? Because that gives our leaders carte blanche.

The standard-issue war movie laments the way war takes from us our best and brightest—in other words,

those who lead us in moral instruction, usually by example. But it's the loss itself, in those movies, that often instructs. It's the loss itself that ratifies the values being pushed. In an unpleasant way, those movies need to both idealize their heroes and kill them. One of the movies Steven Spielberg mentions as seminal to his development is Allan Dwan's *Sands of Iwo Jima*, made during the war and featuring John Wayne as one of those leatherneck sergeants. Some hagiography was to be expected in such a project, of course—it was, after all, a joint production from Republic Pictures and the Marine Corps—but what's noteworthy (and paradigmatic) about *Sands* is how it ends. The island's finally taken. The sarge, finally ready to relax, sits to chat with his men and have a smoke. He's killed by a sniper, who's then himself dispatched. And immediately afterward, as if *generated* by the sacrifice, we see the Marines' most famous and powerful iconographic image, itself, it turns out, historically staged: the raising of the flag on Mount Suribachi.

Our leaders don't *take* carte blanche; they're *given* carte blanche. There is, finally, something oddly honest about the staginess of that framing story that wraps around the main action in *Saving Private Ryan*. When sad old

Private Ryan, standing over Captain Miller's grave, just flat out asks his wife to *announce* that his life was worth Miller's sacrifice, it's as if the movie is acknowledging its self-consciousness about its own nature as an object to be pleasurably consumed; acknowledging that it knows what we want, and what it's giving it to us, and that we know it's doing so, and that it hopes we'll be properly grateful. As though the movie's going, *Aw, heck: I know what you want. Why even beat around the bush? Let's just ask. Let's just pick someone with some authority. "Hey. Mrs. Ryan. You've known him a long time, right? So it was worth it, right?"* And this woman whom we've seen for all of three minutes reassures us.

And if that's true, we're being fooled because we've chosen to be entertained, rather than be made to think. And *since* we've *chosen* to be entertained, rather than be made to think, we're *not* really being fooled.

In other words, we don't necessarily really believe what people like George W. Bush tell us. But we *want* to believe, and we operate as though we do. It's not news that we're trained by our popular culture to accept pleasant fictions. It *is* discomfiting to have to acknowledge every so often, though, just how happily complicitous we are in our own hoodwinking. We're like the audiences filing out of *Saving Private Ryan*,

congratulating ourselves on having been brave and unflinching for having watched a movie that delivered nearly everything we desired. We've been made to feel virtuous for being indulged. What could be better than that? Whether you're selling a movie or selling a war, that's probably the best mousetrap of all.

SACRIFICE AND RAGE FROM
NOSFERATU TO PAT TILLMAN

For the last few decades in America, spectacular ironies have strolled out of the news two or three times a day; even so, one of the more stupefying of the years between 2002 and 2005 had to be the Bush administration's wholesale destruction of its country's military, particularly the Army. I'm not talking about casualty rates in Iraq. I'm talking about policies—avoidable policies—that seemed so systematically self-defeating that it was hard not to see these policies as determined to destroy what we might have expected the neocons to cherish most—the direct embodiment of America's imperial might. What were we supposed to make of that administration's nickel-and-dime stonewalling—*in an all-volunteer Army*—on the issue of sufficient body armor? Or Humvee armor? Or wounded veterans'

benefits? Or on pledges to limit tours of duty? Sure, the *Marines* could be abused and sacrificed without much political cost—those sonsabitches are *crazy*, as one of the grunts half-admiringly reports in Michael Herr's Vietnam memoir, *Dispatches*—but this was the all-volunteer Army. And that rank and file *does* tend to register its own self-interest.

In May of 2005 we learned that the year before, Lieutenant General John Riggs, veteran of 39 years in the Army, recipient of the Distinguished Flying Cross in Vietnam, and a three-star general, was booted out with a demotion—he was retired as a *two*-star general—for having had the temerity to suggest publicly that American forces in Afghanistan and Iraq were stretched too thin. That kind of demotion for straight talk was at that point more or less unprecedented in the military. (Not getting ahead because of straight talk, of course, was commonplace, but *demotion* was not.) And the fact that the administration calculated it could get away with such vindictiveness indicated how satisfied it was with its success at having weeded out anyone unwilling to toe the line, no matter how disastrous that line might be. (This process started much earlier, of course. Remember General Shinseki, head of the Joint Chiefs of Staff, shitcanned in May of 2003 for pointing out what was

then subsequently proven: that the Army's manpower numbers were far too small to pull off what it was being asked to do in Iraq.) So who's left in the command structure of the Army at that point, then? The deafening silence of all but retired officers at the treatment of Riggs made the answer unavoidably clear: only the sycophantic and the cowed. And who are they going to be ordering around? Who's going to be doing the heavy lifting? Well, in terms of the all-volunteer Army: by 2005 this country was already rapidly running out of young men who were so badly informed that they were willing to sign up for an indefinite stay in a meat grinder. ABC News reported that the Army fell *forty-two percent* short of its recruiting quotas that year.

The way this country is currently operating as an imperial power, it *needs* a healthy all-volunteer Army. Having to institute a draft would be catastrophic to the free hand it's been granted to indulge its breezy willingness to practice interventionism. Various far-off wars mobilize little resistance because they seem to cost the American people so little, as far as the American people can tell: not only because we're mortgaging our future, instead of paying the wars' costs as we go, but also because young people who don't want to fight don't have to. Most polls suggested that by 2005

sixty-five percent of Americans believed the war in Iraq to be a terrible mistake. So why weren't more of us out there protesting? Because most of us were willing to pay other people to die for that mistake.

We weren't surprised, then, at the initial play that Part 1 of the Pat Tillman narrative received in the media. Tillman was, as far as Fox News was concerned, the epitome of the citizen-soldier called to his duty to defend his country: he didn't just walk away from a good job; he walked away from the National Football League. I mean, those were the guys our soldiers in Iraq wanted to *be*. And *he* joined *them*. When he was then killed in a firefight, the country mourned and the Bush administration solemnly put him to use: he was still, after all, the man who turned down fame and fortune to make "the ultimate sacrifice in the war on terror," as the White House spokesman chose to put it. Except it turned out that he was killed by friendly fire, and that that had been instantly covered up by both the Army and the Bush administration. (In the immediate investigation following his death, the *Washington Post* revealed, there'd been *fourteen* sworn statements by fellow platoon members saying he'd been killed by friendly fire. Some of his last words, in fact, apparently had been "Cease fire! Cease fire! Friendlies!")

Part of what appalled and radicalized Tillman's family ("They blew up their poster boy," his father told the *Post*) was the baldness of the cynicism behind the cover-up: the palpable sense of disrespect and contempt for Tillman that seemed to be operating alongside the more obvious Machiavellian agenda. Wasn't Tillman, however he died, the sort of figure who this administration held in the highest esteem?

Destroying, with a kind of mesmeric relentlessness, what one claims to value most: a surprising number of film genres operate with that principle at their core. Westerns, for example. Or film noirs. Or horror films.

My loved ones will claim that any number of faintly off-putting idiosyncrasies and just plain characterological oddities on my part can be traced to a defining moment in my childhood when I was left in front of the television at the age of six. My parents were out. My babysitter was less than zealous. I found myself in my darkened den confronting F.W. Murnau's *Nosferatu: A Symphony of Horror*.

Understand: we're not talking here about a movie that's terrifying, exactly. But we are talking about one of the most unsettlingly and insidiously weird movies in the canon. There was a rumor at the movie's release

that Murnau had employed a real vampire in the title role. The rumor seems to have come about for at least three reasons: first, the way the guy *looked*. And *moved*. Audiences were, um, taken aback. A common response seems to have been something along the lines of "What the *hell* am I looking at?" Second, the guy's name: Max Schreck. ("Schreck" means *horror* or *terror* in German.) And third, which was just a PR flack's invention, it was claimed that no one knew the guy, or knew of any other roles he'd played. The rumor is also understandable to anyone who's seen the movie because Murnau, art director Albin Grau, and screenwriter Henrik Galeen all must have rummaged around in their psychic basements in order to help Schreck generate a performance that's conversation-stopping in its sinister strangeness and dignified repulsiveness. If there's any character in film history who seems to have wandered in from another world, it's Schreck's Nosferatu. He's like an unfunny parody of a human. (Which is exactly what a vampire is supposed to be.) At any given moment, he's like a rat, or a spider, or a skull, morphed *into* the human.

For their plot, Murnau and Galeen pillaged Bram Stoker's *Dracula* (without worrying themselves about permissions), and the vampire's liminal status as outlined by Stoker—is this thing dead or alive? Part of our

world, or not?—was beautifully suited both to unnerv-
ing six-year-olds left alone in darkened rooms, and en-
abling Murnau's stylistic experimentation. Most of his
first nine movies are lost, and he owes his status among
movie nuts to *Nosferatu* and the movies that followed
it—especially *Der Letzte Mann, Faust, Sunrise,* and
Tabu. (He was killed in 1931 before the premiere of
Tabu when his Packard overturned outside Santa Bar-
bara.) He's usually credited with having been the first
to understand the expressive potential of the moving
camera, in *Der Letzte Mann.* With *Nosferatu,* he was
looking for ways to make his vampire's presence even
more unease-producing. And he hit on the idea of de-
signing individual shots—referred to as "tableaux" by
his peers—*not* only as static compositions but also as
spaces continually open to every sort of intrusion and
transformation. You want liminal, in visual terms? *Nos-
feratu* gives you liminal. Murnau turned it into a com-
pendium of comings and goings, of slightly alarming
trajectories, of reminders that there was *always* stuff
outside of the frame that the viewer couldn't see: stuff
that might be worrisome, and stuff that was *in motion.*
Horror films have taken advantage of that knowledge
ever since.

So each character in the movie has his or her own way of moving, and of making visually tangible what each represents. Hutter, Stoker's Jonathan Harker figure, is all doltish energy and precipitous rushing about, always active and never effective. His somewhat long-suffering wife, Ellen, on the other hand, responds to the world with a resigned and somnambulant grace. Nosferatu himself, meanwhile, as Jack Kerouac—another fan nearly undone by having seen the movie at too early an age—pointed out, maintains the stillness of a figure in a bad dream or a spider on its web. He rises from his coffin like a plank. He ascends stairs with an awful, quick-footed walk. His shadow spreads across walls and bedclothes like an ink stain. He appropriates and contaminates whatever space he's in. His initial stalking of Hutter is rendered from Hutter's point of view in a series of dissolves that mimic the mechanism of nightmare, as the vampire's figure doesn't move, but even so becomes progressively larger. As in: *it hasn't shifted, but it keeps getting closer*. And then in one of the most disturbingly beautiful shots in film history, the vampire's quietly insidious arrival in Bremen is heralded by his ship's smoothly innocuous glide into an otherwise static and placid long shot of the harbor.

The movie keeps operating by bringing together stuff no one expected to see brought together, or by operating in that middle ground between them. Murnau hybridized two entrenched approaches to moviemaking that seemed opposed in the early twenties: the expressionism of German movies like *The Cabinet of Dr. Caligari*, and the fascination with the sweep and luminosity of nature on display in Scandinavian movies of the same period by people like Carl Theodor Dreyer and Victor Sjöström. Murnau discovered that the real world already offered everything anyone needed to shake somebody up. *How* something was photographed made all the difference. So off he and his cinematographer trooped with their camera, and what they came up with in its own quiet way turns out to be all about the permeability of the border between the familiar and the uncanny. *Nosferatu's action* often takes place in a bucolic natural setting, and, the longer we stay in it, the more it seems to operate, as one critic put it, "under the shadow of the supernatural." There's an oblique neutrality to shots of waves in the moonlight. We witness the balked jumpiness of horses in a field. We sit with Ellen on some windswept dunes spotted with listing and canted crosses. Apparent tranquility is infused, while we watch, with an underlying unease and dread.

And yet we *still* haven't gotten at how truly weird *Nosferatu* is.

And to do that we have to start talking about how often characters in the movie seem peculiarly excited before there's any apparent reason to be, and how often they seem oddly *un*excited after there seems *plenty* of reason to be. The scenes between Hutter and Ellen feel bizarrely charged even before he leaves for the castle. Knock, the house agent who's Hutter's boss, seems to be practicing a kind of homespun and psychotically intense private diabolism before the vampire even arrives on the scene, or in the movie. And then once the vampire does appear, whole scenes are staged seemingly to establish the characters' bizarre indifference to his presence. Hutter, attacked during the night, examines the two holes in his throat in a mirror the next morning and chuckles. Having learned that the vampire is on his way to his wife and hometown, he escapes the castle and then noticeably dawdles in his race home. (We crosscut multiple times between the vampire's ship, surging along in full sail, and Hutter on horseback idly picking his way along a forest trail.)

The movie's very structure seems to insist that we not single out the vampire as its only source of anxiety. Once Nosferatu arrives in Bremen we abandon him to

spend eight full minutes on the plague that's accompanied him, and then yet more minutes with Knock, who's institutionalized like Stoker's Renfield and then escapes and is pursued around Bremen looking like Mr. Pickwick on a rampage. So Nosferatu—this dread, ghastly vision of pestilential evil—has come to the hero's hometown, and the movie loses interest in him for *fifteen full minutes.*

What's going on?

The same thing that seemed to be going on in the Bush administration. Elements were combined that didn't work together, that logically cancelled one another out but that nevertheless possessed for their creators a kind of dreamlike power. In *Nosferatu* the narrative assumes a more metaphoric than logical purpose. Normal reactions—normal causalities—don't occur, and repeatedly the same figurative point is asserted: polarities that we would expect to maintain themselves—polarities like purity and corruption, or innocence and knowledge, or desire and repulsion—are breaking down. So that, again, the morning after Hutter is attacked during his first night in Nosferatu's castle, he notices the marks on his throat in the mirror and smiles. The next night as his baleful, implacable host looms over his bed, we cut to Ellen in Bremen,

sitting bolt upright in her bed, stretching out her arms and calling to her husband. But it's the *vampire* who responds, turning from his prey and gazing offscreen in a perfect eyeline match, thereby confirming the movie's insistent and subversive implication that the pure at heart are as much on the monster's wavelength as those already given over to perdition. (We're shown in multiple ways that the diabolic Knock *and* Ellen are from the very beginning sensitized to the vampire's approach.) Our unease and disorientation in that Ellen-calling-out-to-the-vampire scene is increased by our dawning sense that the explanatory intertitles at times *misrepresent* the images: "*Hutter, far away, had heard her cry of warning,*" we're told immediately after Ellen's call has apparently lured Nosferatu away from her husband. But her sleeping husband didn't hear a thing. In other words, *Nosferatu* poses the question at the heart of expressionism: Where does the infected soul stop and the world begin? Hutter and Ellen, reunited in Bremen, kiss, and the movie immediately cuts to a close-up of Nosferatu—!—in another location. He smiles.

The world is an extension of my sensibility; the world is what I say it is. All logic—what logic is left,

then—proceeds from that. Anyone who's sat through one of the Bush administration's press conferences registers something familiar in that formulation. And for those who missed the implication, various spokespeople for the administration spelled it out. *All empirical evidence seems to point to A? We say B. Next question?*

The world is as I say it is, and I have no doubts as to my primary values. And yet my actions will work to undermine or even overthrow those values. And so the Western hero, who says he has to live free and unfettered in a world that enables that freedom, spends most of his movie making the world safe for the kind of community that will have to banish him or make him obsolete. The hard-boiled private detective fetishizes his isolated independence as his greatest source of strength, and then repeatedly tumbles into the femme fatale's transparent snares. And horror movies, valorizing virginal innocence above all else, revolve mostly around the deconstruction of that innocence.

There's some serious and bizarre ambivalence here, operating just beneath all of the claims of straightforward clarity, in other words. In the case of Murnau's *Nosferatu*, it's not hard to see why; the filmmaker was, after all, semivoluntarily exiled from his family because of his sexual orientation, an exile that left him feeling

both an active and respected member of his society and something else altogether. He would have been aware of the Slovakian legend that vampires came from the ranks of those excommunicated from the church, or their lives: suicides, heretics, apostates, and those cursed by their parents. And he certainly must have registered at least what Stoker did: the usefulness of vampirism as a way of animating the unspeakable.

It's instructive to note what Murnau *didn't* take from Stoker. He dumped Stoker's Christian metaphysic entirely. None of the sacred ammunition that *Dracula* provides—communion wafers, holy water, or cruci-fixes—have any role at all in Murnau's movie; instead, *Nosferatu*'s contribution to the genre is the destructive power of daylight. With sunlight, nature itself takes care of a problem that seems to be a dark parody of its own fertility. ("*From the seed of Belial,*" we're told, the vam-pire has sprung, and he sails to Bremen on a ship called the *Demeter*.) The vampire's particular kind of liminal status, in other words, depends on being cloaked, on some form of secrecy. The light of day dispels it.

So this particular vampire, not very surprisingly, becomes readable as a grotesque and frightening form of desire, a version of the awakened or indulged wish that's both irresistibly powerful and catastrophically

dangerous. The figure of Van Helsing, the Good Doctor, representing rational science and hardy, masculine, can-do industry, is completely ineffectual in Murnau's version, dozing through the climactic crisis and arriving too late to help. Instead, in Murnau's version, Ellen—the embodiment of ultimate value that everyone else has sworn to protect and uphold—faces the threat alone.

The movie does everything it can to maximize our surprise at that news. We make a stunning transition from that long and irritating and frenetic digression of the townspeople's pursuit of the escaped Knock to an unexpected and startling head-on shot of Nosferatu, utterly still and gazing out at us from his window. (He's rented an outrageously creepy and dilapidated house that sits directly opposite Ellen's homey and sunlit little cottage, like a real estate version of the unconscious.)

Ellen bolts awake. Hutter, who's supposed to be on guard, naturally does not. So she wakes him. Instead of pointing out to him the thing from the pit of hell that's looking at her from across the street, though, she sends him for help. And without asking why she *needs* help—or looking across the street—he rushes off. She lurches around the room, agonizing. We're given more shots of the vampire, looking at us from his window.

Then she throws open her window and turns from it, her face in her hands, having invited him in.

It turns out that she's read, in *The Book of Vampires*, that only a woman who is pure of heart *and willing to give herself to the vampire* can lift its curse.

He leaves the window. She staggers drunkenly, her head still in her hands. His shadow mounts a staircase. His shadow pauses outside her door, its fingers extending elastically across the wall to the knob in a visualization of the vampire's defiling reach. In bed, with him still offscreen, she jerks her head down in anticipation of his touch, and the shadow of his hand and arm spread upward across her white dressing gown. We crosscut between the perversely intimate and understated image of him feeding at her neck in a long shot and Hutter, once again, *not* hurrying back (!) with a groggy Van Helsing in tow.

Her sacrifice succeeds: poor Nosferatu is caught by the cock's crow, loses his malevolent power, and staggers around in the sunlight like Uncle Morty having a coronary. He dissolves, the same cinematic technology used to create him erasing him.

But then the most disturbing—and often unremarked-upon—turn occurs. Knock, apparently returned to his cell, pronounces his master's death.

Hutter continues to stroll home. Ellen lasts long enough to fall into his embrace upon his return, and she dies in his arms, her sacrifice complete. He grieves on her bed while keeping one foot primly on the floor. The intertitle announces *"At that very hour the Great Death ceased and the shadow of the vampire vanished as if overcome by the victorious rays of the living sun"*: the good news everyone's been waiting for. Except Murnau was careful to have it follow *not* the monster's death, which took place *four scenes* earlier, but *Ellen's* death. It's *her* death, we're reminded, that *The Book of Vampires* said was required, and *her* death that abolishes the taint.

Which brings us back to that Bush administration.

Nosferatu's aggression toward its female lead and paragon of virtue is the same sort of aggression you can sense lurking behind sentimentalities like *she was too good for this world*. We might note that such sentimentalities are not only pieties, but slippages of responsibility as well. If someone *is* too good for this world, then it's probably no one's fault that they're no longer in it. That's the sort of comforting logic that the reader confronts in discussions of Little Eva, Tiny Tim, and Pat Tillman. What separates the third name on that list from the first two is how explicitly the

responsibility for his death can now be attributed to those who claimed to so cherish his value. (And how cynically and vehemently that responsibility has been denied.) When the Bush administration talked about sacrifice, it did so with a weird doubleness, an edge. The all-volunteer Army was doing precisely what the major figures in that administration—from Donald Rumsfeld to Dick Cheney to George W. Bush—refused to do, whatever their past or present rhetoric about the glories of sacrifice. We're very grateful to those who sacrifice for us, and grateful as well to those who embody the virtues to which we claim we most aspire. And we're enraged with them, as well, for all they demonstrate to us, through the example of their behavior, about ourselves.

CHINATOWN AND THE TUNNEL AT THE END OF THE LIGHT

You know, I was an apocalyptic before, but by George W. Bush's second term as president, I thought, this is getting ridiculous. The situation in our country—and the situation our country led the way in creating around the world—started to look so undeniably untenable that it seemed to create a kind of perverse optimism: wherever you looked, people in opposition to the administration and what it so flagrantly represented were taking heart. Given that global warming, or the mainstream media's abdication to its corporate controllers, or congressional corruption, or the assault on Americans' civil rights was by even then so *evidently* out of control, the thinking seemed to be that the pendulum should be swinging back the other way any day now, now that enough people of conscience

had been educated and galvanized by the spectacle. Every monarchy produces a bad king occasionally, right? But the system is self-correcting, isn't it?

Sure, if that's what you want to think. Who am I to say otherwise? But here was *my* fear, as the Bush administration's second term wound down: that our political culture had by that point created a mess that was so *unprecedentedly* debilitating and insoluble— and that adverb was the key variable that made our situation beyond the ability of institutions like the *New York Times* to grasp—that, once our present leaders were tossed out and the hapless opposition, in whatever form (moderate Republicans? Some sad version of stay-the-course Democrats?) got their hands on the wheel, they'd simply be there in the driver's seat when we hit the tree. Or trees. Maybe if they were lucky they'd do what they could to diminish the impact. And who would be standing by and looking on with their arms folded, no longer adhering to their enraged principle that in tough times the country needs to rally behind its president? Our friends on the extreme right, who would either still have, or would take back, control of the Republican Party. And they'd still control as well large portions of the media: a media that would begin, the moment the Bush administration finally *left* office,

to scathingly judge the inadequacy of those in power. If we never stopped hearing about A Presidency in Crisis when that diagnosis was based on comparative *trivia* like Whitewater, I could only imagine what sort of ammunition consistent bad news from an unpopular *war* would provide. And it wasn't hard to predict that Fox News's method of spinning imperial setbacks was going to be to claim that everything had just been turning around when we cut and ran: a fantasy position *much* more appealing to most Americans than the news that we fucked up and now were paying for it. Which would then lead to a restoration of the extreme right.

In other words, in that model, the more things head into the toilet—whether or not the right is directly responsible—the more Americans, bewildered, upset, resentful, and threatened—will turn to the right for solutions. The right, after all, offers Order. It offers Strength. It offers a Return to the Old Values. It offers to do away with complexity. It offers to continue to let us embrace a fantasy of omnipotence. Its motto is: *We should never as a nation blame ourselves for anything. We should always blame others*. Think that motto has power in hard times? Ask the Germans.

This vision of an America that generates debilitating and self-reinforcing and therefore insoluble

messes has a cinematic model, cranked out forty-three years ago now and still the gold standard for clear-eyed understanding of the *Hey, nothing personal* malevolence of late model capitalism: Roman Polanski's *Chinatown*.

Forty-three years ago a worrisomely jaded Polish emigre director and a notoriously saturnine screenwriter teamed to produce a movie seemingly constructed to instill in its audience a startling amount of despair, a despair that was only somewhat mitigated by the exhilaration provided by the filmmaking. Roman Polanski—about whom the critic Andrew Sarris remarked, "His talent is as undeniable as his intentions are dubious"—and Robert Towne—whose scripts specialized in turning a stubbornly jaundiced eye on American ideals—ended up detesting each other, but out of the backbiting came *Chinatown*, a film noir of legendary design (Towne's script is, famously, the Bible for aspiring screenwriters) and influence.

Chinatown popped up during that mini–golden age of American moviemaking centered around the early seventies, another one of those periodic historical moments when it had again dawned on Americans that we had let certain aspects of our everyday corruption and

hypocrisy get out of hand. A lot of the best movies produced in that tiny window of opportunity—from Sam Peckinpah's *The Wild Bunch* to Robert Altman's *McCabe & Mrs. Miller* to Martin Scorsese's *Mean Streets* to Bob Fosse's *Cabaret*—were deeply invested in the traditional American film genres, but not interested in genre demolition or parody as much as renovation from the inside: in both playing out and interrogating the genre's rules.

So in *Chinatown*, everything we expect is there, and Jack Nicholson is Jake Gittes, the private eye with a past working out of his office in L.A., and soon enough he comes across Faye Dunaway's Evelyn Mulwray, the mystery woman who's all smooth control, coolly serene sexual independence, and transparent deception, and everybody's enmeshed in a satisfyingly labyrinthine plot.

Except something's off from the beginning. Even though both stars, thanks to cinematographer John Alonzo, have never looked more glamorous, private-eyeing has apparently been pretty seriously de-romanticized. The movie begins with our riffling through some photos of a man and a woman having sex in the woods. Jake's delivering them to a fat sweaty guy who's been suspicious of his wife. Humphrey Bogart's Sam Spade, who helped create the private eye

archetype in John Huston's *The Maltese Falcon* in 1941, let us know in no uncertain terms that he specifically prided himself on *not* doing divorce work. How did he make his money? Oh, you know: every so often a jewel-encrusted priceless figurine stolen centuries earlier from the Knights Templar happened by.

Jake, on the other hand, spends the movie's first twenty minutes peeking in windows and scrabbling around rooftops with a camera. Divorce work is his *métier*, as he somewhat pathetically informs Mrs. Mulwray later. He's got a squalid and banal job, and people judge him for it: "You got a helluva way to make a living," one pillar of the community tells him in a barbershop, and while that kind of comment would occasion only a wisecrack from Sam Spade, it causes the insecure and humiliated Jake to fly off the handle and offer to take it outside.

He spends a lot of time *earning* that contempt, though. A surprising amount of the time he's left looking like an idiot. As he also explains to Mrs. Mulwray, "I'm not supposed to be the one caught with his pants down." And in terms of his genre, he *isn't*. But in *Chinatown* he almost always is. The-rank-and-file cops treat him like a guy who could not have a more pathetic way of earning a living. He tells a long,

embarrassingly vulgar joke to his cronies without re-
alizing that Mrs. Mulwray's been waiting behind him.
He's taken in entirely by a second-rate actress who
makes him a pawn in discrediting an honest man.
(We remember that women lying were never, for Sam
Spade, a problem: "Well, we didn't believe your story,
Miss O'Shaughnessy; we believed your two hundred
dollars.") The movie's working, in other words, to strip
him of a certain portion of his dignity. Private eyes
need their personal style, and what another critic, the
previously mentioned Robert Warshow, said the West-
ern hero understands, the private eye understands, as
well: "A hero is someone who looks like a hero." And
however much Jake is determined to continue to look
like a hero with his fedora and sunglasses and Man of
Action seriousness of purpose, there *is* the problem,
after he gets his nose slit open, of this big white clown
bandage on which he has to perch his shades for pretty
much the rest of the movie.

Very few movies have made *such* expert use of Jack
Nicholson's persona. (The role *was* written for him.)
That tension between being the coolest guy in town
and looking like an idiot has always been a part of what
he projects. And in this case, sure, he's got all these
limitations and he doesn't seem to be doing so well

in terms of avoiding embarrassment. But he's still got that smile and those eyebrows, and that insouciance, and that *joie de vivre*, all of which not only work their usual magic but also win us over to the likelihood that he probably *is* the best man in his world. He's competent, he's smart, he's more honest than most, and he's gallant in his own hard-boiled way. None of it does him much good.

Mostly because of what he's facing. At a county commissioner's hearing early on we discover that Los Angeles is built on a desert and is in the midst of a drought. Water, it turns out later, is being diverted from farmers who desperately need it in order to drive them out of business and devalue their land, making it, then, easy pickings for those in the know. That particular plot point was based on a real conspiracy in which businessmen and politicians connived to force through a water legislation scam. A scam startlingly similar to a recent massive energy crisis in California that turned out to be no crisis at all, which made millions for those who engineered it. Hmm. What's that old saying of Marx's about history? First time tragedy, second time farce?

★

The earlier scam was, for Robert Towne, the perfect image for the perverse omnivorousness of capitalism. Water itself—the staff of life—was the commodity that was to be hoarded, manipulated, and denied. *Hey, there: Want the stuff that allows you to live? Well, I own it.*

The offhanded perverseness and bottomlessness of that kind of greed was one of the main reasons for the peculiarly understated ferocity of *Chinatown*'s nihilism. (And ferocious nihilism is in my experience a pretty unusual characteristic in a successful, and even much loved, commercial film.) It certainly represents a worldview most of us would refuse to accept. And therein lies the opportunity, as far as malefactors are concerned.

Jake's like us: he thinks he's been around, thinks he's cynical, thinks he's well aware that people are mostly out for themselves. But for all his confident professionalism, he's no more ready for what gets unfolded than we are. And the movie's careful to dramatize the somewhat glacial pace at which he does start to figure things out.

Early on we follow him through puzzling and endless stakeouts of Mrs. Mulwray's husband (the good man he unwittingly discredited), during which we learn, like Jake, all sorts of critical information without

knowing it. After Mulwray is murdered, the solution to the crime and the keys to the conspiracy all pass by on display in crucial clues which he, and we, overlook. He spots a glint that turns out to be eyeglasses in Mulwray's saltwater pond the first time he visits, but is distracted from investigating; later he's informed that Mulwray, who supposedly drowned in a runoff culvert for rainwater, had saltwater in his lungs. Everywhere he goes, Jake sees and ignores symbols representing the Albacore Club, the organization the bad guy is using to mask his plan.

But when we remember the scene of Jake telling his joke, we're reminded that he's not only someone who doesn't always see everything he needs to—Mrs. Mulwray's right behind him, his subordinates are signaling frantically, and in his delight at telling the joke, he never catches on—he's also someone who, at crucial times, doesn't know how to *listen*. So that the process of detection in the movie, and its structure, becomes a matter of having to return to places we've been before—nearly every location gets visited twice—in order to discover what we missed the first time.

He never does figure it out, and neither do we. Finally, we're all just flat-out *told* what we need to know, by the principal malefactor, Noah Cross, and

the principal victim, his daughter, Evelyn Mulwray. It turns out that the perversity of that unappeasable acquisitiveness in the public arena has been mirrored in the private one, and the child that Cross has hired Jake to find is the daughter he fathered with his own daughter. The way Towne or Polanski might put it is that what Noah Cross is intending to do to Southern California, and his granddaughter, he's already done to his daughter.

Noah Cross is played by John Huston, the man who directed the already-mentioned *Maltese Falcon*, so he's returning here like the genre's unnatural father—speaking of incest—and presiding over a movie that goes on to kick the floor out of film noir precisely the way the Bush administration kicked the floor out of our everyday expectations of the corrupt malevolence of politicians.

"You may *think* you know what you're dealing with," Cross warns Jake early on. "But believe me, you don't. Why is that funny?" And Jake explains his knowing chuckle by responding, "It's what the district attorney used to tell me in Chinatown." And Cross answers, "Yeah? Was he right?" To which Jake doesn't respond.

Once Jake thinks he has cracked the case, he confronts Evelyn Mulwray and starts to reenact the

ending of *The Maltese Falcon*: he calls the police to come and arrest her, and uses the pressure of their imminent arrival to try to demand the truth, or in other words, demand she acknowledge his version of events, his mastery of the puzzle, by confessing to what he's already figured out.

But he's not in that kind of world anymore. And neither are we. The femme fatales in film noir are supposed to harbor a steamy secret; this one, however, turns out to reside a few subfloors below what we've come to expect. And Evelyn turns out to have been as powerless in the face of forces like Noah Cross and what he represents as Jake is. Jake, whose specialty has been families' sexual secrets, has stumbled across something here that's topped everything: long-term, incestuous rape.

But that would still only constitute an extra seamy flourish without the hammer of the ending. In Towne's original screenplay, Jake sees his efforts do some good: Evelyn shoots and kills Cross and gets away with their incestuous offspring while Jake occupies the police. In the version Polanski filmed, which Towne referred to afterward as "the tunnel at the end of the light," Evelyn, in trying to escape, is shot through the back of the head. This we discover when Jake reaches her car and

reveals the gaping exit wound through her eye. Noah Cross then wraps his tentacles around his screaming daughter/granddaughter and carries her off, in what has to be one of the more unregenerate moments in American film history. And what makes it worse is that Evelyn dies not only despite Jake's best efforts, but *because* of them: he's the one who chose this strategy of escape, and he's the one who threw himself heroically across the arm of the good cop, who was shooting at Evelyn's tires, which caused the bad cop to take matters into his own hands, and aim higher.

At that moment *Chinatown* feels like the culmination of a trend noticeable throughout the development of film noir: the notion of the powers that be as increasingly so omnipotent, malevolent, and successfully masked that they turn all of the protagonist's core virtues into liabilities. And here once again we find ourselves returning to points relevant to discussions of America in its late-capitalist phase. In *Chinatown*, the criminals *are* the system; the junior highs and municipal projects are named after them; and standing against them is not only futile but directly harmful. Looking at the body of his lover, Jake can only murmur what we were informed the district attorney advised his men to try to accomplish when working in

Chinatown: "As little as possible." Advice that Humphrey Bogart's Sam Spade in *The Maltese Falcon* would never have accepted has now become a lesson his descendant has had to learn the hard way.

Protagonists of the American action genres—the Western, film noir, the war movie, etc.—are all *about* the meaningful individual act as a means of redemption or self-definition. If that's taken away, those figures have almost nothing left. In *Chinatown*, that's taken away. Perhaps no American movie ever worked with such cruel ingenuity to demonstrate not only the futility of good intentions, but the catastrophic consequences of well-intentioned intervention, when the system is so thoroughly rigged.

The ending has such force because, like Jake, we too never learn; despite all indications, we assume things will at least not collapse *so* horribly. When you mentioned to most people just a few of the towering problems that the second Bush administration either created or hugely exacerbated—from its *Hey, let's break everything in sight* intervention in Iraq to the long-term wreckage of its economic policies to its stupefyingly irresponsible position on global warming— the polite response you received usually ran along the lines of "Well, I'm sure something will work out." Sure,

things look grim now, but there's no reason to get all Chicken Little about it; after all, professionally trained members of the elite, men of sobriety and experience, were no doubt at work on the problem even as you spoke. Surely not *so* much damage had been done that some Brent Scowcroft types couldn't turn this thing around. Like Jake, we want to believe that we've seen this movie before and know how it goes. But in *Chinatown* we're stunned to discover that our surrogate really *is* in over his head, because the system has long since evolved into something that's not looking to address aberrant criminality. Reformers are allowed to operate—up to a point—not because they have powerful allies among the forces for good but because of the system's sense of its own invulnerability.

But we'd been making such *progress*. And we'd gotten *real dirt* on the bad guys. Hadn't we been about to turn this thing around? Jake's increasingly decisive sense that he knows what he's doing, his righteous rage, and his and our understanding that private eyes *solve* these cases and *set* things aright—after all, he's clearly seen *The Maltese Falcon*, too—combine to make the final scenes' nihilism all the more devastating.

Given Roman Polanski's own gothic phantasmagoria of a life—he witnessed as a child the liquidation

of the Kraków ghetto and the execution of his parents, and emigrated to the United States only to have his wife, Sharon Tate, and their unborn child butchered by the Manson family—he was probably psychically well-situated to demonstrate to Americans just how deeply romantic a supposedly cynical form like film noir really was. And it's hard to come up with another American movie that's delivered such sumptuous and glamorous visuals underpinned with such sordidness and corruption. Or that has exposed such darkness with such gleefulness.

The charitable term for Polanski's humor is macabre. There are endless visual jokes foreshadowing what's going to happen to poor Evelyn's left eye: on a stakeout, we follow a kicked-out left taillight; we view a pair of watches, the left one crushed; everyone's glasses seem to get their left lenses smashed; and just before they become lovers, Jake is distracted by "something black" in Evelyn's left eye. A flaw in the iris, she explains. And probably the nastiest joke in a long string of nasty jokes involves an early escape from some bad guys that is staged precisely like Evelyn's attempt to escape at the end: the bad guys fire at her car as it disappears into the darkness, seemingly to no effect. That first time around, though, as we watch Jake and Evelyn drive

away unscathed, Evelyn, after a moment, picks delicately at her left eye, as if to mime, *Hmm. There seems to be something in my eye. Could it be: A bullet?*

How perverse *is* the humor? Well, Polanski himself plays the guy who slits open Jake's nose on camera to warn him off pursuing the case. Polanski was Sharon Tate's husband. What should we make of the associations that he had to know we'd bring to the image of him slitting people open with a knife?

Is there something funny about naked ruthlessness, and a self-consciousness about the power to generate suffering with impunity? Did you notice how much Donald Rumsfeld *enjoyed* some of those press conferences in which he scattered absurd double-talk like chicken feed before a befuddled press corps? Have you found yourself wondering why Dick Cheney would have clung so tenaciously to a method of interrogation—torture—that had been so long discredited as a working method of gathering intelligence?

Late in *Chinatown*, Jake asks Noah Cross, "Why're you doin' it? How much better can you eat? What can you buy that you can't already afford?" Cross answers, "The *future*, Mr. Gittes. The *future*. Now, where's the girl? I want the only daughter I've got left. As you found out, Evelyn was lost to me long ago." Jake asks,

"Who do you blame for that? Her?" And Cross answers, "I don't blame myself. See, Mr. Gittes, most people never have to face the fact that at the right time and the right place, they're capable of *anything*."

And the obscene and leering overemphasis that Huston puts on his delivery of the final word makes clear that Cross is not *only* ashamed and attempting to rationalize; he's also *delighted*. He's found himself in a new world, here—a world of near-boundless power over other human beings—and it's a *playground*.

There aren't too many comic visions black enough to encompass that kind of insight, but Polanski's is one of them.

Another thing we tend to overlook when experiencing *Chinatown* is what we heard during that county commissioners' hearing at the very beginning. Cross is not only looking to make millions; he's looking to make millions building a dam that will not hold; a dam whose identical design has catastrophically failed before. So it's not just a matter of corruption triumphing; it's a matter of corruption's triumph also setting the stage for inevitable public cataclysm. Mike Brown at FEMA is a bad joke and a run-of-the-mill leech until Katrina comes ashore. Once that happens, he moves into the Nero category, and *a lot of people die.*

All those closet romantics who wish to situate *Chinatown* safely within the noir tradition that preceded it are fond of reciting to each other what they believe to be the film's final line: Jake's assistant's ministering, and preemptively elegiac, "Forget it, Jake; it's Chinatown." That line's famous for a reason. We all recognize the familiar appeal of its squint-eyed tough-guy stoicism. The movie's actual last lines, though, belong to Jake's friend the good cop. What *he* shouts, off-screen, as darkness closes over everybody, is a lot less reassuring, and it's a lot more fitting, given the nature of this world. It's what Americans have been hearing for decades now in our Rust Belt, and in our inner cities, and everywhere else that late-model American capitalism has already decided isn't worth saving. And unless we start paying attention better than we have been, and acting on what we learn, it's what Americans will be hearing in many more places—probably everywhere, in fact, that there isn't a walled compound, with a gate—in the future: "*Get off the street. Get off the street.*"

THE VANISHING AND AMERICAN SOCIOPATHY:
Just Because You Did Something Doesn't Mean You're Capable of Doing It

A SIMPLE NIGHTMARE IDEA

In 1988 a bizarre little Dutch thriller disconcerted enough people on both sides of the Atlantic to generate some serious word of mouth—so much, in fact, that its director, George Sluizer, was handed a pile of money a few years later to remake an American version. About that second version, the less said the better. The first, though, earned itself a cult following of not only connoisseurs of the *killer next door* subgenre but also of *cineastes* transfixed by the intricacy of the narrative structure and the icy persuasiveness of the central performances. Both versions had the same title—*The Vanishing* (*Spoorloos*, for those of you following along in your Dutch-English dictionaries)— but the first version accomplished something that

almost no other examples of that subgenre have been able to pull off: it left audiences demolished by the extent of their *implied* identification with what had taken place on screen. Of course, all *killer next door* movies by definition aspire to that: *there's a little killer in all of us*. Oooo: and we all give a little shiver. But until *The Vanishing* no movie had so smoothly and implacably led an audience to a glimpse of the size and casualness of its capacity for sociopathy. And it's the casualness of that sociopathy that seems to me so reminiscent of where Americans are today, as our society has finally begun to register in a widespread way what our elected officials have in our name brought down on all sorts of people in all sorts of places. Having registered that, we've gone about our business. Many—maybe most— of us have experienced regret, or distaste, to be sure. But meanwhile those elected officials have gone, and are going, about their business, unprosecuted. And what are most of us doing about it? Well, a number of us are complaining to one another. Put me down in *that* category. And there's also been a lot of shopping.

The Vanishing spins out of an appealingly simple little nightmare idea: a quasi-happy young couple, Rex and Saskia, pull into a rest stop in France on a cycling

vacation. After they hang out for a little while, Saskia heads into France's version of a QuikMart to buy them a beer and a Coke. She never comes out.

What happened to her? Rex spends the rest of the movie trying to find out. *We* find out almost immediately, at least in terms of who did it. We *don't* know, however, what he did. And of course, we want to know almost as much as Rex does.

It turns out that Raymond, placid family man and infinitely comfortable petit bourgeois, is behind her disappearance. In our first glimpse of him, he's in his car working his hand through a false plaster cast, apparently in the hope of faking a broken arm, when Rex and Saskia are pulling into the rest stop. He seems fastidious, frowning in serious-minded concentration over his goatee. We register him noticing them afterward, standing about with his ersatz arm sling. And after a harrowing seven minutes of screen time spent alongside an increasingly distraught Rex trying to negotiate the sheer impossibility of his girlfriend's disappearance, the narrative shifts to Raymond, dressed like a businessman and carrying a small bottle to what looks like a neglected house in the country. The house in the country turns out to feature a family, and while we watch, he and

they set a table outside, for a dinner in the yard. An affectionate if slightly fussbudgety dad and his wife and two teenaged daughters sit down to a nice meal. One daughter opens a shallow drawer in the table and shrieks: it's crawling with spiders. Raymond scolds her: they're not only useful; they're adorable, lovable animals. And that was a really beautiful scream, he adds. Can he hear it again? She gives it a shot. Both daughters alternate trying to outdo one another in volume while the mother looks at each of them, disconcerted and uneasy. Then she's asked to contribute, and after a hesitation, she screams, too. Raymond seems to approve; then, to be a good sport, he shrieks. We cut to the next day and a neighbor chatting with him. Raymond wants to know: his family thought they heard screams. Had the neighbor? No, the neighbor tells him. He hadn't heard a thing. Raymond smiles, pleased.

Now we cut to what we gradually understand to be Raymond's experiments: alone at that country house, he pours something from that little bottle onto a handkerchief, checks his watch, and holds the handkerchief over his nose and mouth. Later, he checks the duration of his unconsciousness. Dosages, etc. are recorded in a little notebook.

We slowly come to realize that he's teaching himself predation. He practices his blocking, his moves, and his come-into-my-parlor conversation, around his car: working it all out. It'll take too much time, he realizes, if he doesn't have his handkerchief ready; he'll need to make sure the bottle's stopper doesn't open in his pocket; he'll need to reach over to lock her door as the pretext for getting close enough to overpower her. Still pondering the complexities, he checks his watch and realizes he's late. We cut to him picking up his teenaged daughter from school and letting her into the car exactly as he just choreographed. Once in the car with her, he reaches over to lock her door, just as he rehearsed, and bear-hugs her, just as he rehearsed, except this bear-hug ends in an affectionate hair-mussing rather than incapacitation.

When his daughter wants to know what's up with the door locking, he tells her: Didn't she read in the papers about that girl? The one who fell out onto the highway? That's terrible! the daughter says, with enthusiasm. What happened to her? Is she dead? Come now, think about it, he chides her. At that speed, and on that surface, what else could have happened to her? The daughter thinks about that, satisfied. They're both eating chocolate éclairs.

THE UNHEIMLICH IN THE HEIMLICH

The German word *unheimlich* is considered to be untranslatable, and our rough English equivalent, *uncanny*, is not so easy to define, either. The indescribability is the heart of the uncanny experience: it's unsettling and/or terrifying precisely because it *can't* be adequately explained. Freud focused on the way the uncanny derived its terror not from what we might expect—the alien or the unknown—but from the strangely familiar. In fact, he tracked the paradox back to its linguistic roots, and it turned out that *heimlich*, which had as its first dictionary definition: *Belonging to the house, not strange, familiar, tame, intimate, friendly; arousing a sense of agreeable restfulness and security*, had as its second: *Concealed, kept from sight, so that others do not get to know of or about it, withheld from others.* And: *Secretive, deceitful, and malicious.*

In other words, *heimlich* contained within itself the kernel that undermined the primary condition that it was supposed to create or provide. So that *unheimlich* was a subspecies of *heimlich*. Or here's another way of putting it: inside what we thought we were sure of was the opposite of what we were sure of. Inside the everyday was what the everyday suppressed or overlooked.

Bernard-Pierre Donnadieu plays Raymond, the sociopath at the heart of the story, as the sort of guy who generates indulgent smiles from women: not very masculine, slightly fumbling, with that extra politesse designed to mask the neediness in his gaze. He's proud of his competence, but he always seems to have a little something extra to prove. The movies have been fascinated with the covert murderousness of the petit bourgeois at least since Fritz Lang's *M*, which made Peter Lorre a star for his role as the anonymous child murderer Hans Beckert. But it's instructive to examine just how reassuringly visible—and different from his audience—Lang *made* his protagonist in that film. First of all, he *cast* Peter Lorre, a walking expressionist cartoon who looks and sounds, thank God, like no one you or I have ever met.

But equally importantly, we don't really see Beckert operating as a smoothly functioning member of society. He goes unnoticed for a while, but that's partly because Berlin is clearly filled with some *other* pretty strange-looking people, as well, and partly because he mostly hides out in his room, or behind thick hedges in out-of-the-way cafes. When he *is* around little girls—his primary targets—he looks like a blind dog in a meat market. His difference—his abnormality—is

not actually coded as invisible. People *do* notice him, and, slightly disconcerted, continue on their way. His strangeness is unpursued mostly because it's such a big city. *The Vanishing*'s Raymond is the kind of guy who'd go unnoticed even in a *lineup*. Raymond goes everywhere and does everything and he's the last guy anyone would suspect as abnormal, *because he's so normal*. (At one point, as he and a friend gaze at Saskia's missing-persons flyer, he reminds the friend that he'd once asked, "What if *I* had done it?" And the friend had laughed in his face.)

What's going on, here, though, is more unsettling than the standard revelation of a secret life. For Raymond, the murderousness grows *organically out of* what he would call his nurturing love for his family. His identity as a loving family man in fact empowers and enables his murderousness. He works out a trailer scam as part of his rest stop plan: he'll approach lone women and ask them for help hitching his small trailer to the back of his car. This fails, humiliatingly, when women (and in one case, a hostile and suspicious husband) wonder aloud why he needs help from a woman. It's his family, though, that helps him figure out the scam's fatal weakness: their loving commemoration of his life on his birthday occasions the photo

album through which he pages until he comes across a snapshot of himself with a broken arm. At which point he realizes he needs to seem weaker or more in distress to trap his prey.

It turns out that his status as family man also empowers him because it moves him out of the realm of the *unheimlich* and into the realm of the *heimlich* in the eyes of his potential victims. Toward the end, when we finally get to see what happened to Saskia, and Raymond tells her to get in his car right before he attacks her, she's smart enough to hesitate, to sense something wrong. But what reassures her, and wins her over, is his photo of his family. Which hasn't been deployed there specifically to fool her; it's just from that other part of his life, like the kitchen tiles for a planned renovation dumped in the back seat.

The uncanny nature of the sociopath, who operates like a fully healthy human being, except for when, within that normality, the most horrifying kinds of abnormality erupt, is nicely conceptualized by Freud's essay on the uncanny. And also by *The Vanishing*. Saskia, we learn at the very end, has been buried alive in the yard of Raymond's country house. She's under the lunch table. In retrospect, then, we overlay that scene of bourgeois placidity and domesticity we

witnessed earlier with the boxed-up and buried horror that was always beneath it. That's as helpful an illustration—a schematic—of the uncanny as you're going to find.

And then we remember that that same contrast between what was apparent and what was hidden inside the apparent was enacted on a smaller scale even in that earlier scene, by the drawer full of spiders. Which Raymond defended as not only useful but adorable. His word choice is eloquent about the paradoxes he can hold in his head, in terms of his sense of himself as a family man: *spiders* are *adorable*. And a pleasant family picnic staged over a body buried alive ends up seeming a pretty good schematic of Raymond's psyche.

Okay. But so far that sounds like a lot of *killer next door* movies. *The Vanishing*'s weirder than that, though. Because that family picnic over a body buried alive also turns out to be a schematic of *Rex's* psyche. And by extension, one of the primary ways in which movies work. And by extension, one of the primary ways in which our country, lately, works.

"HITCHCOCK IN A BERET"

The missing-persons poster is the movie's way back to Rex's story, which was abandoned soon after Saskia's

disappearance. After the scene of Raymond's gazing at the flyer, we cut to Rex stopping a car at an intersection in order to check out another one. He's been obsessing about the disappearance for three years now, and climbing back into the car with his new girlfriend, he says something we might expect, followed up by something that seems kind of stunning. He tells the new girlfriend, while they drive, "Sometimes I imagine she's alive. Somewhere far away. She's very happy. And then I have to make a choice. Either I let her go on living and never know, or I let her die and find out what happened." He looks over at the girlfriend coolly and smiles. "So . . . I let her die," he concludes. "I don't feel like being a part of a ménage à trois," the new girlfriend complains in response, somewhat missing the point. And we have to take a moment to think about what Rex just said, as in: *Wait a minute. Did I just hear that right?*

Any movie about a sociopath has, we expect, inexplicability at its core. But as we get further and further into the movie, it's the *hero's* behavior that seems more and more inexplicable. If what Raymond is doing is in some acknowledged way inexplicable—after all, who can know why sociopaths do what they do?—what our hero Rex is doing is increasingly, in an *unacknowledged*

way, nearly equally inexplicable. He's obsessed about her disappearance for three years. He's spent a fortune trying to find her. He's refused to move on with his life. *Why* is he doing what he's doing? He says he really loves her. He tells an interviewer it's a kind of tribute: he calls it an homage. But a tribute to who, or what?

Their scenes together before her disappearance all turn out to center around Rex's seemingly unmotivated irritability and cruelty. As they drive, the camera lingers on her application of her lipstick, and his irritation with that; he even rudely raises her sun visor mirror. She gives him a look and lowers it again. She notices he's low on gas when they pass a gas station, but she doesn't say anything. He seems annoyed by the implicit notion that she might be judging his decision and asks what she's looking at. She tells him. He snaps back at her, "Just look in your mirror." A few miles later, in a tunnel, they run out of gas. It seems to further enrage him that she was right: he *should've* gotten gas. When she asks what they're going to do, he tells her, somewhat hysterically, not to get hysterical. She makes the perfectly reasonable point that she's not hysterical; she's scared. She's scared, she tells him. So what's his response? To *leave* her there, alone, in the dark and in, he claims, serious danger. He tells her they've got to get out of the tunnel, given that

oncoming traffic might see them there only when it's too late; she says they have a flashlight and begins looking for it, he tells her to stop, and when she doesn't, he leaves her behind, crying and shouting his name. We hear her voice behind him in the darkness as he walks: "Rex, don't leave me here alone. You can't leave me here alone. Rex, wait!" And what's his reaction? *He smiles.*

In a movie that also features one of the creepier sociopaths in film history, this is in fact its most quietly unsettling moment. What's our hero *smiling* at? Why *is* he abandoning her? What *is* his thought process, exactly? *Come with me; it's too dangerous where we are. You're hesitating? Fine. Stay here and die, then.*

The more we examine their time together, the more we realize that Saskia, when she's around, generates all sorts of unruly anxiety in Rex about just who he is and what he's like. He believes he loves her, that he thinks the world of her, and he *acts* as if he feels horribly boxed in by his connection with her, and can barely keep his aggression under control.

That image of her panicked and crying and trapped in that tiny little car in retrospect is an image of where Raymond left her finally, as well. And as Rex walks away from her and her increasingly panicked protests, it's her *shriek* that generates his smile. As in: *You're*

243

terrified: I like that. And: *You need me now: I like that.*
And: *I'm free: I like that.*

After they're speaking again, at the highway rest
stop, she straddles him on the ground and commands
him to repeat after her: he values her. He will never
abandon her. And we can see that he's charmed and we
can see how much he cares about her, and he agrees to
all of that. And her affect, after she receives his pledge,
is suddenly hauntingly sad. As though she knows he
won't be able to keep it. And here's a thought: that ex-
pression on her face at that moment is part of what
fuels his obsession after her disappearance. Because
what he *saw* on her face was her understanding that
in all probability, he *wasn't* going to keep his promise.
And she didn't believe she'd eventually be abandoned
because she anticipated her own abduction. She be-
lieved it because of something she *already understood*
about him.

In one of their first scenes together she complains
to him that she's had her recurring nightmare again:
the one about herself inside a golden egg in which
she feels as if she's doomed to be alone forever. In
the dream, she tells him, the loneliness is unbearable.
Hmm. Maybe, her analyst would say, she's not only
talking about Raymond's trap.

If that's true, then part of what Rex is seeking through his determination to never give up on finding her—even after he understands that she's almost certainly already dead—is an ongoing self-ratification. He *did* love her. He *didn't* abandon her. He *is* a good person. He can prove it: he never quit looking for her. He may not have acted as though he valued her when she was around, but by god, he'll fix that now that she's gone. He stages himself as someone who, no matter what, will never give up, because in some ways he knows how much he *wanted* to give up. He remembers, in fact, the alacrity with which he gave up before.

And in not giving up, he gets to both preserve his feelings for the object of his devotion and keep his distance from it. As though he were in a golden egg right next to hers. After having abandoned her in the tunnel, he tries to make it up to her by telling her that *that* was when he loved her the most. *Then*: when he was abandoning her.

Inside the rock-solid, the bottom drops away: that colloquial definition of the uncanny seems to be Rex's inner experience of his feelings for Saskia. It's startling how often he makes explicit that he's *not* looking to recover her. He never *does* say he wants Saskia back. What he keeps saying he wants is *knowledge*. He wants

to *know* what happened. And he'd rather *know* than have her back. Whoa. That aligns him with Raymond, who says he does what *he* does partially so he can *know* if he can do it, and what it would feel like. And that makes him similar to us, as well.

Detached curiosity and absorbed identification that still leaves the viewer in a position of safety: Where would the movies be without them?

Explaining his mysterious passion for visiting their country house, Raymond tells his wife: "You start with an idea in your head. Then you take a step. Then a second . . . Soon, you realize you're up to your neck in something intense." Not a bad account of the way thrillers operate.

Rex doesn't *need* to have Saskia back; he doesn't even seem to *want* to have Saskia back. He needs to *know*. And the movie works hard to generate that impulse in us, as well. Which brings us to its narrative structure: it's not a whodunit—we learn the *who* very early on—and yet it still generates suspense. Partially because we want to know what will happen between Raymond and Rex. And partially because, like Rex, we want to know what happened to Saskia. And is that because we're concerned about her? Not exactly. Or not entirely. Like Rex, we're already more or less sure she's been killed.

The Vanishing was repeatedly compared to Hitchcock's movies—Sluizer described it as "Hitchcock in a beret"—and that seems understandable; like a movie like *Vertigo*, it's a thriller about knowledge, and what's disturbing is not what the characters *don't* know about the crime, but what they *do* know about it. And about themselves. Which allows us, as we watch, to make some uncomfortable connections to what *we* want and do. And what the movies do *for* us.

A PERVERSE BUDDY PICTURE

The Vanishing continually teases us with knowledge about to be revealed, often by leaving Raymond in Rex's close proximity again and again, unnoticed. Part of Rex's torment is the way he's being toyed with by the unknown killer: five times he's been sent postcards instructing him to go to a particular spot, all near the site of the abduction; five times Rex has gone and had no idea who, around him, is the murderer. One of those times is dramatized for us: Rex and his new girlfriend, sitting grimly around a café. Rex tells her his greatest fear has become that the murderer will stop sending him cards. Because then he'll never know. And as though responding to that fear, the camera begins to track around behind them. While the track continues,

his girlfriend warns him that the murderer's playing with him; that he just wants to see how far Rex will go. "He's having a blast," she tells him. "We'll see," he answers. And we do, and don't: once behind them, we can see, between them, standing placidly on a balcony in the distance, a torso we assume to be Raymond's, hands on the railing, checking them out. The framing doesn't allow us to see the head. We cut to a reverse shot from behind those hands on the rail: there's Rex and his girlfriend in the distance, their eyes on the other café-goers. And we're made aware of our desire to see, and the way our desire was only half-satisfied.

Although the narrative more or less splits its time between Raymond and Rex, and although Raymond's the one we see, in flashback, trying to figure out how to abduct and murder someone, *Rex* is the one who spends the movie continually agitated. As though *he's* the one dealing with the unspeakable. As indeed he is. Saskia disappears fifteen minutes into the movie. Raymond reveals himself to Rex about an hour in, *and they remain together until the end, approximately forty-five minutes later.* Which means Raymond and Rex spend *three times* as much time together as Saskia and Rex do.

It's supposed to be a triangle—Raymond having come between Rex and Saskia. But Rex and Raymond

spend way more time together, and way more time together *comfortably*, than Rex and Saskia do.

The Vanishing turns out to be, in its own perverse way, a buddy picture. It divides its narrative between two points of view: not perpetrator and victim, unless we adopt Rex's solipsistic view that *he's* the victim. That he's the one who's been robbed of something. And what is it that he doesn't have, that he wants? He confirms it, with Raymond: not Saskia. Knowledge. Raymond seems to recognize a kindred spirit in Rex, the same way Rex does in him, despite himself. Part of what so interested Freud about the uncanny was the way, as he saw it, its premise of the unfamiliar within the familiar staged the collapse of the psychic boundary between the self and others. For Rex, the unknown is *not* just what's in the mind of the criminal. All through the movie, he does all *sorts* of things that *need* some explaining, all of which he leaves unexplained. (What *is* his explanation for why he left Saskia in the tunnel? He doesn't offer one. He tells her instead only that he's sorry.)

What's animating him, though, is a fear of Saskia, and that seems even harder for him to face than his attraction to Raymond. For Freud the uncanny had such power because it exposed knowledge already present

but repressed. When it comes to Saskia, Rex's emotions could not vary more wildly, from the intensely loving to the murderous. No wonder, then, that he finds the even-tempered nature of the sociopath so fascinating.

Interviewed about his obsessions, when asked what kind of person he believes the murderer to be, his response sounds like he's designing a personals ad: he thinks—no, he amends, he's sure—the man's very intelligent. At this point Rex smiles warmly into the camera. And the man's a total perfectionist. Rex's admiration and his certainty are both a little, well, disconcerting. How does *he* know what that person is like? What information does he have? He's extrapolating. Or projecting. If he has no information, then it's all his fantasy. And the movie *makes* his fantasy true. Every way in which he characterizes Raymond, on the basis of almost no information, turns out to be accurate.

Freud would suggest that the essence of uncanny is something in the unconscious that is manifested in reality. Saskia's dream vision was her entrapment in a golden egg. Rex tells us, in that interview, that he's started having that dream as well. Raymond, watching the interview on television, very likely gets his idea of what to do with Rex—how to solve Rex's problem—by

hearing about Rex's dream. Their future, in other words, explicitly comes from the dream they each share. For Saskia, it's a nightmare. For Rex, it's an endless source of fascination. That may be why Saskia is so sad when she asks him to never abandon him.

THE COCOON OF COMFORT

As others have pointed out, we view movies in the theater with a dreamlike receptivity, in the dark, sitting back, looking up at the screen in an experience that's like hypnosis: a temporarily regressive mental state in which we're allowed to merge with what we're watching. On the one hand, we're in a state of enforced passivity—we can say, after a gruesome moment in a horror movie, *I* didn't want to see that!—and on the other, we register that those impulses we're viewing on-screen are inside us somewhere, when it comes to our own psyches. It would be one thing if we went to see a musical and it turned out to be a slasher film. It's another when we go to see a slasher film and then claim that we didn't want to see what we saw.

So how's this for a model of the way we relate to what we see on screen? Raymond's first sociopathic act was jumping from a high balcony when he was a boy. Before jumping he said to himself, *Imagine you're*

jumping. That thought experiment gave him permission to jump. Rex, having heard that story, uses it himself, later, to persuade himself to put his faith into a sociopath's hands in order to get the information he says he wants. Raymond tells him: drink this sleeping pill, and you'll know everything. What's implied is: *I'll do to you what I did to her. And it's the only way you'll find out.* Of course Rex realizes how crazy it is to act on those terms. But then, so did Raymond. And of course, in the audience, we're sitting there calling out, "Don't do it; what are you, nuts?" But think about how disappointed we'd be if Rex walked away from the offer, and the movie ended there.

Raymond as a boy on that balcony projected himself into an imagined situation as a first step toward doing the unthinkable. Rex decided to do the same thing. Because they know they're projecting, they can pretend that they're just trying things on, that they're spectators first. It's a way of hanging on to the notion that you're not responsible even as you ease yourself into an act for which you *are* responsible.

The *Detroit Metro Times* around 2006 interviewed Scott Ritter, an ex–Marine Corps intelligence officer and chief UN weapons inspector in Iraq who'd been trying to sound the alarm about his country's apparent

determination to repeat its catastrophic interventionism with an attack on Iran. At one point, the reporter asked why, in the face of everything that was general knowledge by then, there seemed to be no groundswell of outrage about or opposition to the plan. And Ritter in response reminded him that:

> very few Americans actually function as citizens anymore. . . . Americans are primarily consumers today, and so long as they continue to wrap themselves in a cocoon of comfort, and the system keeps them walking down a road to the perceived path of prosperity, they don't want to rock the boat. If it doesn't have a direct impact on their day-to-day existence, they simply don't care.

Do we know what's being done in our name? Yes: mostly we do. I know, I know: many of us are not that well-informed, etc. But take Iraq: nearly everybody in America knew by 2006 that something like between tens of thousands and hundreds of thousands of men, women, and children were *dead* because of our intervention and that that intervention was *not* based on reasons that were quite as urgent as advertised. And here's the thing: even knowing that, we remained

serene in our knowledge that we were still good people. Yes, however-many thousands have been killed because of leaders we tolerate. And yes, that may even be happening for no good reason. But does that make us *bad people*? No; of *that*, we're sure. We have our own *sense* of ourselves, to prove it.

As does Raymond. Part of his placidity comes from his understanding that he's not the sort of person who murders. He's murdered someone, yes, but as *The Daily Show*'s Rob Corddry memorably put it a few years ago on the subject of Abu Ghraib, what the world needs to understand about Americans is that just because we *did* something, that doesn't mean we're capable of *doing* it.

Raymond's wife and daughters are meant to experience their picnic as *heimlich*: Dad's an affectionate provider, and they're enjoying the good life at their summer home. But even they feel perturbations in the field: they each ask about a secret life of his that they sense. They just get the specifics of the question wrong. None of their questions bother Raymond. As far as he's concerned, he's a good man who did a hideous thing. This interests him about himself, but not unduly.

That need to maintain denial is very powerful. Which is why we follow Rex, our hero, for so long while still minimizing his weirdness. "Weirdness" in this case being better defined as aggression—at times murderous aggression—toward the woman he claims he loves. We would prefer not to notice such things about characters with whom we've decided, even temporarily, to identify.

And our enforced passivity gives us permission to feel all sorts of unpleasant things. Just before the movie's climax, we're made privy to what we've most wanted to see: what happened between Raymond and Saskia. And if we'd overlooked that the movie's design had been teasing before, we certainly don't miss it this time around.

Saskia goes into the QuikMart for her beer and her Coke and stops at the coffee machine, needing change. Raymond hovers nearby. And again he fucks up, and our long-awaited resolution seems delayed: he hesitates; she buys a Frisbee and heads back out; he's mobbed by a busload of kids and can't get to her before she leaves.

He tries with someone else. She seems a likely victim; she even volunteers to get into his car. About to climb in himself, he sneezes into his hanky after

having put the chloroform on it. Recovering in the men's room, he has to laugh at himself: he's really bad at this predator thing. (This is now at least the seventh woman with whom we've seen him fail.) He takes off his sling and pockets it, as if resolving that maybe he's just not cut out to be a psycho murderer.

But back Saskia comes, still looking for her drinks. And it's significant that he doesn't seem particularly focused on her, or predatory, during her initial requests for change. And he doesn't try to pursue the matter when she tells him to never mind, that she'll just get change from the cashier. In fact, his long look after she again leaves seems to suggest regret more than anything else.

When she returns with the change, he's at the edge of the frame, sipping his coffee and very assiduously *not* looking at her. To emphasize that, we get a medium shot of him looking down and allowing himself only one surreptitious glance. Then we cut to her holding up both cans and proclaiming her happiness. She tells him how nice it is to speak French; he tells her her French is very good; she says he's a liar. Is that right? she asks him, testing her pronunciation. *Is* he a liar? That's correct, he tells her. And because of her bad French, she points at his keychain, the one with the capital R his daughter gave him for his birthday,

and says, "Look at me." (She wants one for Rex, but can't pull off the "Look at that!" Apparently she's been reading film criticism about the way in which, in movies, women are the object of the male gaze.)

So he *does* look at her. And as she tells him about her love for Rex, we can see Raymond starting to really like her. His stated purpose, he confided earlier, was to do the most horrible thing of which he could conceive. And *that* would involve killing someone he thought was pretty wonderful. Someone who *really* didn't deserve to die. He looks down, and thinks about it, and she's toast. We get to see him decide.

One of the movie's achievements is that at that moment from a flashback—she's been missing for years, according to the narrative, and we're finally about to see what horrible thing happened to her—*then* she's at her most attractive, and most appealing. It's a part of the movie's manipulative design that *right there* is where we like her the most. Right before, like Rex, we lose her forever. Johanna ter Steege won the European Academy Award for her performance, and that scene is the main reason why.

As she keeps after him, about change at the coffee machine, and then about her French, and then about his keychain, and how much she loves her boyfriend,

we're surprised and dismayed by how much she's getting *herself* into trouble, and *that* makes us feel some of Rex's rage, and some of his tendency to blame her for what happened. We're both touched at how likeable she is, and frustrated at her persistence—why does she have to be so *charming*?—while we watch her reawaken Raymond's predation. *Why does she have to be so charming*: that seemed to have been *Rex's* complaint about her, as well. That was the form his fear of her seemed to take. Which suggests that when Raymond abducts her, he's not only appalling us but acting out our aggression, as well.

So Rex's *real* agonized question throughout the movie is not *Is Saskia okay?* Or even *What did the killer do to her?* It's more *What's up with what I want?*

Well: he doesn't want to know. His realization of that propels him into a situation that serves as a punishment. For him, when it comes to that, knowledge is dangerous. Raymond can prove it: Raymond's a sociopath who's already murdered someone, and Raymond tells him, *You'll have to turn yourself over to me to find out what you think you want to know*. And Rex does. Part of what Raymond is selling with his offer is control of Saskia through her conversion to information, to knowledge. And he's also offering a stabilized separation that operates as a kind

of proximity: *I'm not saying you'll have Saskia back. I'm saying you'll know what happened to her.* Unbeknownst to Rex, Raymond is about to bury Rex in a box, just as he buried Saskia. The boxes will be side-by-side beneath the picnic table. If Rex has been frightened by the notion of merging in some fundamental way with Saskia, Raymond is here to allay that fear. Raymond in fact can give Rex what he most wants—*knowledge*—and punish him for it at the same time. *And* Raymond can guarantee that Rex can always stay near Saskia, and always stay separate from her.

Early on when talking about her golden egg dream, Saskia told Rex, as if channeling his anxiety, that later in the dream there'd been two eggs, and that Rex had been inside the other, and that she'd felt like "if we were to collide, it'd all be over."

The amount to which Rex understands that helps explain some of his most inexplicable actions when he realizes what's happened to him at the end. Taking stock of the fact that he's been buried alive, he not only reacts with shock and horror. He also laughs. And he also, even *more* surprisingly, announces his identity. "I'm Rex Hofman!" he shouts at the top of his lungs. Uh: okay. Why is *that* an issue at this point? How

many people do *you* know who would, waking to find themselves buried alive, feel the need to announce their name? Rex does. No more of that merger-with-the-woman stuff for *him*. He's not part of a pair. He's just Rex Hofman.

Those twin golden eggs about which he dreamed represent not just an ironic final frustration, but also his fondest wish. What Dante described as a lover's situation in hell—the two alongside one another, imprisoned so that they could never touch—Rex describes, when he first recounts his dream, as something that's fascinating and unsettling but *not* undeniably horrible.

Rex's psyche has conjured Saskia's disappearance much the same way that Raymond's has. And Raymond is Rex's surrogate in the same way that he's ours: we want to disavow him, but we don't *only* want to disavow him.

After the tunnel, Rex vowed never again to abandon Saskia, but he knew in his heart he already had. And that's the knowledge he'll do anything not to have to face. On some level, he'd always known that the killer had been acting as his surrogate. Some version of himself never stopped musing *Saskia is too threatening: I wish she and everything she represents would go away*. And *poof*: Raymond complied.

When thinking about ourselves as an aggregate, we Americans cherish the notion of our benevolence toward the rest of the world. That benevolence extends so far in our minds' eye that it can even, for some of us, provide cover for our ferocity and destructiveness: hence General Westmoreland's famous remark about having had to destroy a Vietnamese village in order to save it. For most of us, though, the repression takes a simpler form. We've already colluded with our media when it comes to that knowledge we'll do anything not to have to face. We want all of those casualties—all of that proof of our failure to live up to our own capacities as human beings—to just go away. And *poof*: they do.

JIM SHEPARD is the author of seven novels, including *The Book of Aron*; five story collections, including *Like You'd Understand, Anyway*—a finalist for the National Book Award and winner of the Story Prize—and editor of the anthology *Writers at the Movies*. He lives in Williamstown, Massachusetts, with his wife, three children, and three beagles. He teaches at Williams College.